IMAGES
of America

VERNON
TOWNSHIP

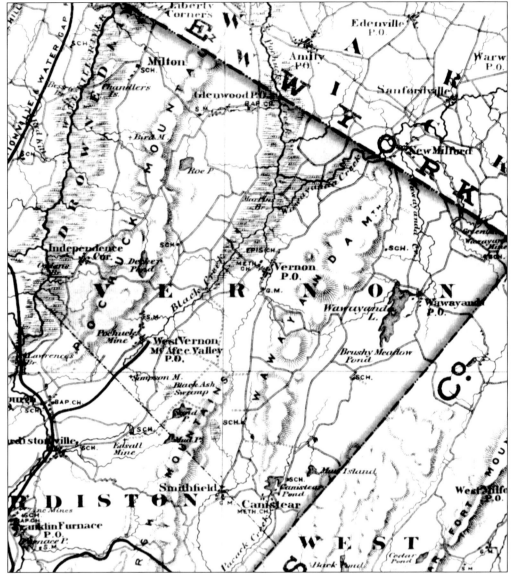

VERNON TOWNSHIP IN 1876. This 1876 map of the township is from the Frederick W. Beers *State Atlas of New Jersey*. (Author's collection.)

On the cover: **TRAINLOADS OF PEACHES AT GLENWOOD.** Peaches are loaded onto cars of the Pochuck Railroad at Glenwood *c.* 1905 (see page 86). (Courtesy the Antique Photo Store.)

IMAGES
of America

VERNON
TOWNSHIP

Ronald J. Dupont Jr.

ARCADIA
PUBLISHING

Published by Arcadia Publishing
Charleston SC, Chicago IL, Portsmouth NH, San Francisco CA

Printed in the United States of America

Library of Congress Catalog Card Number: 2002109304

For all general information contact Arcadia Publishing at:
Telephone 843-853-2070
Fax 843-853-0044
E-mail sales@arcadiapublishing.com
For customer service and orders:
Toll-Free 1-888-313-2665

Visit us on the Internet at www.arcadiapublishing.com

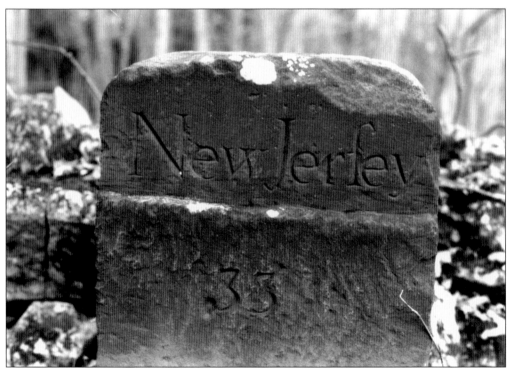

NEW JERFEY? The New York-New Jersey boundary stone No. 33, shown here, was erected in 1774 following the long and bitter boundary dispute with New York State. It marks the actual spot on the border that is 33 miles from the Hudson River. The *f* is not an error, but merely the common 18th-century rendering of a small *s*. The stone is located in the Price's Switch section of Vernon, adjacent to Warwick, New York. (Author's collection.)

CONTENTS

ACKNOWLEDGMENTS

I am truly humbled by the generosity and trust extended to me by those who lent their invaluable photographs and postcards for use in this book.

The Vernon Township Historical Society gave me full use of its photograph archives, for which I thank Joan Magura, president; Myrtle Hanke, curator; Dolores Dobbs, who helped hunt down a number of photographs for me; and the other officers and trustees of the society.

Marcela T. Gross of Warwick owns probably the premier private collection of historical Vernon photographs, postcards, and memorabilia. She and her husband, Steve, gave me full access to this invaluable trove, without which this book would have been difficult or impossible to complete. I am deeply indebted to them.

Wayne T. McCabe of Newton, himself one of Sussex County's foremost historians, likewise gave me free access to his excellent collection of Vernon postcards, many of them very rare. I am most grateful for his assistance, for which this volume is far better.

Art Jordan of Augusta, proprietor of the Antique Photo Store, graciously allowed me to use prints he made from original A.J. Bloom glass-plate negatives in his collection. Bloom was an outstanding photographer, and his negatives have found an equally outstanding printmaker in Art Jordan. I encourage anyone interested in local historical photography to visit Art Jordan's Web site, *www.antiquephotostore.com.*

Jack McLaughlin, general manager of the Highland Lakes Country Club, gave me access to the club's first-rate collection of historical photographs, including many items originally from the collections of John R. Seckler, former president of the Vernon Township Historical Society. Carolyn Bove lent invaluable original photographs of High Breeze Farm and the Barrett family. Jack and Peg Kurlander, with the assistance of Anne Fitzgerald, kindly lent photographs of the early days of Vernon's ski industry, of which they were an essential part.

Jennie Sweetman, to whom all interested in Sussex County history owe so much, lent rare images of the school and churches of Canistear from her collection. Harvey Barlow was kind enough to lend postcards from his outstanding collection. Others who provided photographs or assisted include Dick Stevens, Carol and Dan Kadish, Catherine Drew, David Drew Jr., Sally Drew, Shirley Dean, Diane Banks, Nancy Krauss, Hank and Sue Capro, Ethel Van Duzer and Dorothy Ji, Dick Conklin, Dan and Deborah Ely, C.H. Coster Gerard, Jamie May, Chris Rohde, Pat Mindos, and Glenn Scherer. My editor at Arcadia, Susie Jaggard, was ever helpful during the entire process.

Lastly, I thank my wife, Emilie J. Dupont, who proofread the manuscript, made many valuable suggestions, and persevered through the gestation of this project while she was enduring a more vital and taxing one of her own.

INTRODUCTION

In the autumn of 1792, citizens of the northern part of Hardyston Township submitted a petition to the governor to establish a new town where they lived. Traveling south to Hamburg to conduct town business was time-consuming and inconvenient for them, and the governor and legislature agreed. On November 19, 1792, Vernon Township was born.

Encompassing everything from rough mountain terrain to fertile, well-watered valleys, our topography defined our history. In the 1700s and 1800s, prosperous farms dotted the valleys, and water-powered mills turned raw materials into finished goods. In the mountains, deep mines produced iron ore for furnaces and forges, and forests were leveled for timber and charcoal. Limestone was quarried in the valleys and was used by farmers and masons. In the little villages that grew up where main roads intersected, stores and taverns tended the local trade. Schools and churches were erected to serve the community. The arrival of the railroad led to new growth in Vernon, with limestone and farm products shipped out and summer visitors shipped in.

It was the automobile that opened the next chapter in Vernon's history. Proximity to the great metropolis made Vernon a place for people to escape the sweltering urban streets, providing camps, boardinghouses, small hotels, and summer homes. Better roads prompted development of more than a dozen summer lake communities.

By the 1930s, recreation was an industry in Vernon, and it has been ever since, particularly with the introduction of ski resorts and hotels in the 1960s. With our proximity to the artistic community of New York City, some of our summer residents have been notable indeed.

Vernon began as a small town of villages in mountains and valleys. It has grown—sometimes painfully—into a semirural enclave of housing developments, mountain resorts, and open-space preserves. This is the history documented in the photographs that follow.

More than 40 of the photographs in this volume were taken by one photographer, A.J. (Alvah Jackson) Bloom (1865–1945), a professional who operated out of Andover, and later Hamburg, from the 1890s through the 1930s. Bloom was a prolific and skillful photographer; his images show thoughtful composition, crisp focus, and perfect exposure. Thankfully, many of Bloom's glass-plate negatives survive and are owned by local historians and collectors. Most of the Bloom prints in this book were produced by Art Jordan of the Antique Photo Store using original negatives from his collection.

Many of the early postcards in this book were published by two township merchants, Charles T. Mott of Vernon and Frank A. Mingle of McAfee. Both of these men published a series of postcards of their respective villages from c. 1906 to 1907. Their own businesses were, of course, prominently featured, but they also captured views of other businesses, schools, churches, and

scenes. S.K. Simon Company published a series of "white border" postcards *c.* 1915, and in the 1950s, Bucky McDonnell photographed and published a color series of Vernon and Highland Lakes postcards. We should be grateful to them all for the photographic record they produced.

For me, these photographs produce contrary impressions. The Vernon Township of old seems impossibly different and as vanished as ancient Rome. Yet so much is still there, with so many of the old buildings, landscapes, and places surviving the tornado of the 20th century. It is so different, yet so much the same. Such a contradiction is probably to be expected of Vernon, where population has grown tenfold in 40 years, yet where there is more protected open space now than ever before.

Choosing the photographs that appear in this book was an unenviable task. For every photograph selected, there were two more for which there was either no time to borrow or space to print. For every photograph owned by the Vernon Township Historical Society or by collectors, there are untold more sitting in shoe boxes and attics. As such, these photographs are presented merely as highlights of what was readily available, featuring quality over quantity. For omissions of notable pictures and places (and there are many), I apologize to all. I encourage anyone with historical photographs of Vernon to contact the Vernon Township Historical Society, so that our visual heritage can continue to be preserved and shared for future generations.

One

HOMES AND FARMS

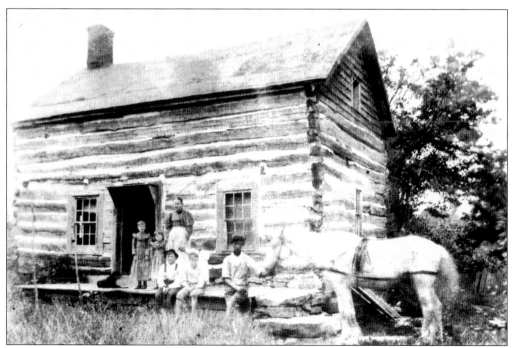

ORIGINAL RUSTIC. This Pochuck Mountain log cabin was probably built by Atkinson Park *c.* 1837, and it stood near the intersection of Glenwood Mountain Road and Parks Lane. Log houses, common in Vernon from *c.* 1730 to *c.* 1900, were built first out of frontier expediency and later as inexpensive housing. The Park Log House stood until 1992 when, threatened with demolition, it was studied and dismantled by the Vernon Township Historical Society and Montclair State University. (Courtesy Vernon Township Historical Society.)

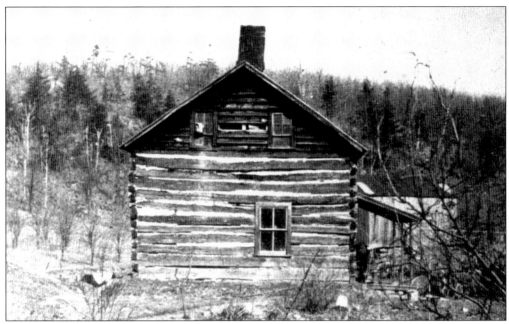

HARDSCRABBLE FARMING. Seen here is a 1930s side view of the Park Log House, illustrating its log construction. Few areas could be less conducive to farming than the rocky summits of Pochuck Mountain. However, by the mid-1800s, many small mountain farms like this one produced hay, livestock, timber, and other agricultural goods. (Courtesy Nancy Krauss.)

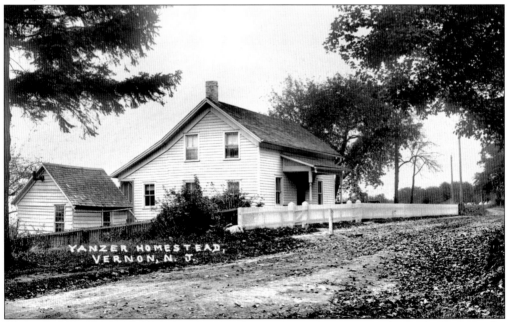

THE YANZER HOMESTEAD (AND BARBERSHOP). Herman Yanzer operated a barbershop on the lower level of his small house on Route 94 opposite Gary's Vernon Lodge *c.* 1900. Said to be one of the oldest structures in Vernon village, the structure still stands. (Courtesy the Antique Photo Store.)

THE HOUSE ON THE HILL. This September 1883 photograph by J. Percy Crayon shows the William Parker farm on Sisco Hill, on the right where Route 515 heads up from Breakneck Road. William D. Parker sold the house to son-in-law Grant Sisco, who was town clerk from the 1920s through the 1950s. If you had business to conduct with the town clerk, this is where you went. The house still stands, though it has been somewhat remodeled. (Author's collection, courtesy Harriet Sisco.)

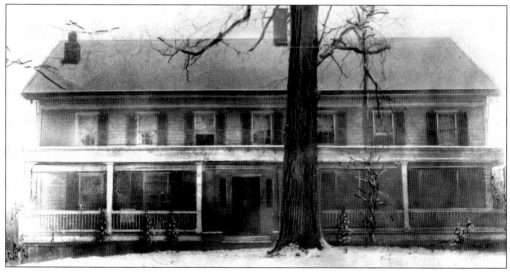

THE FIRST LAND TO BE SETTLED. In 1724, Col. Thomas DeKay purchased 1,200 acres of land along Wawayanda Creek and became our first Colonial settler. His farm on DeKay Road, the Wawayanda Homestead Farm (so called in old deeds), survives, although the present farmhouse was built by the colonel's great-grandson, Maj. Thomas B. DeKay, in 1827. Shown here in the 1930s, it was later remodeled with large white columns in front. (Courtesy Highland Lakes Country Club.)

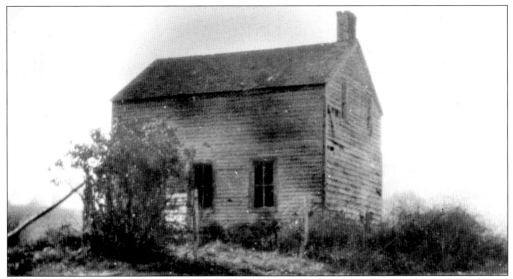

THE EBENEZER DREW TENANT HOUSE. This small tenant house on the Seeley Storm farm stood on the corner of Route 517 and Lounsberry Hollow Road. Probably built in the 1850s, when Ebenezer Drew owned the property, its location on the corner suggests it may originally have been a tradesman's shop and home. Surviving essentially unchanged into the 1980s, it was demolished when the Storm farm became Storm Estates. (Courtesy Vernon Township Historical Society.)

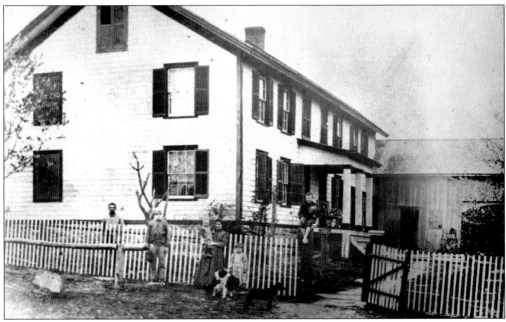

SAY GOODBYE TO THE FARM. In this c. 1900 photograph, Freeman Forgerson and his family stand outside their c. 1850 farmhouse at Canistear. Even though the property was located nearly a mile east of the Canistear Reservoir, which was built in 1900, Forgerson likely knew he was going to end up selling his land to the city of Newark for its vast watershed. Perhaps that is why he had this photograph taken; the house has been gone for a century. (Courtesy Vernon Township Historical Society.)

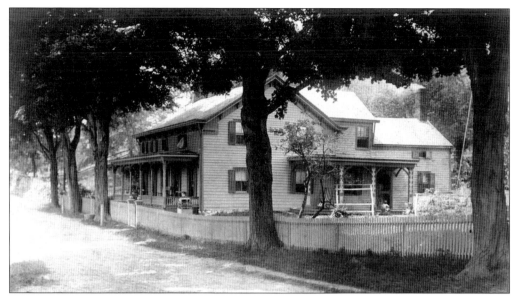

THE ROSEWALL HOUSE. Thomas Rosewall organized the White Rock Lime & Cement Company in McAfee in 1872. He remained its president until his retirement in 1901. His farm on Route 94 in McAfee, later owned by the Fredericks family, was developed as Great Gorge Ski Area (now Mountain Creek South Lodge) in 1965. His house, shown here in a *c.* 1905 postcard view, is the headquarters for the ski patrol. (Courtesy Marcela T. Gross.)

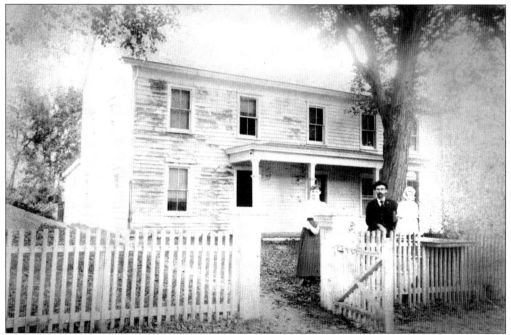

THE MOTT HOMESTEAD. Tenants Katherine and Uhler H. Creveling and their son Henry stand outside the Mott homestead in Vernon in this 1897 view. Creveling was teacher at the Vernon School just up the road. Though covered in vinyl siding, the Mott homestead still stands at 255 Route 94, between Lakeland Pools and the Gulf station. (Courtesy Vernon Township Historical Society.)

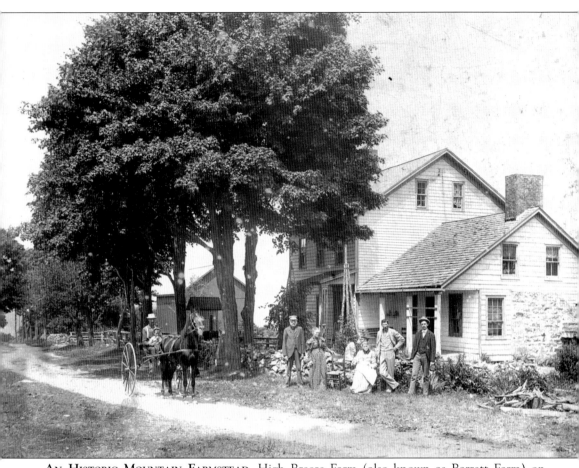

An Historic Mountain Farmstead. High Breeze Farm (also known as Barrett Farm) on Barrett Road dates to *c.* 1828. A typical New Jersey Highlands farm of that era, it was purchased by David Barrett in 1860. Four generations of the Barretts owned the farm (David, James, Ferris, and Luther). The family is shown in front of the main house in this *c.* 1890 photograph, with James E. Barrett in the center. His grandson, Luther Barrett, was a devoted traditionalist and a farrier, or blacksmith, by trade. By the 1980s, the farm remained little changed from a century before. Purchased by the New Jersey Department of Environmental Protection in 1981 as an addition to Wawayanda State Park, the farmstead was originally to be demolished. Its unique reflection of New Jersey's agricultural heritage, with all its various farm buildings intact, led it instead to be listed on the New Jersey Register of Historic Places and the National Register of Historic Places in 1989. (Courtesy Carolyn Bove.)

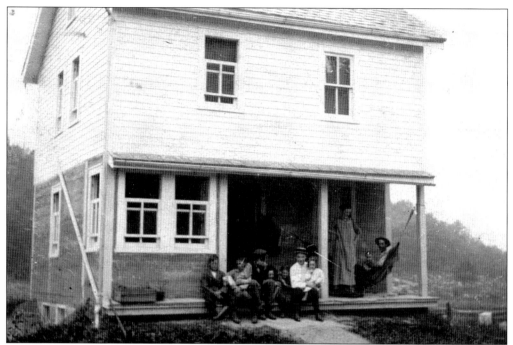

NEW MATERIAL FOR A NEW CENTURY. The Ferris Barrett family of High Breeze Farm built an additional house on their farm in 1909, opposite the main farmhouse. Here, the clan assembles on the front porch. The structure's lower story was built of a then new material: poured concrete, which was strong, rotproof, and fireproof. The building is included in the historic district at the farm. (Courtesy Carolyn Bove.)

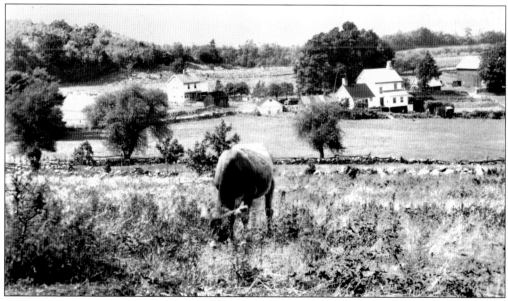

A TYPICAL HIGHLANDS FARM. Much of Vernon's mountain terrain looked like this in the 1800s and early 1900s: rough highland farms. By the 1920s, such farms were increasingly replaced by summer communities and lake developments. Only a handful of such farms—like High Breeze, shown here *c.* 1925—remained intact. (Courtesy Carolyn Bove.)

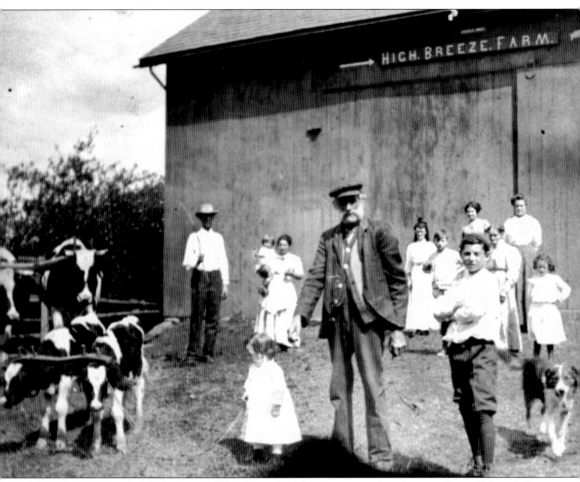

JIM ED BARRETT AND FAMILY. Fiddler, horse breeder, farmer, and innkeeper, James Edward "Jim Ed" Barrett (with a cap and muttonchop whiskers) stands in front of the lower barn at High Breeze Farm in this *c.* 1910 photograph. With him are family members, who include son Ferris (left), training a young pair of yoked oxen; aunt Marty Rood, daughter-in-law Blanche; and grandson Ray Buchanan. (Courtesy Carolyn Bove.)

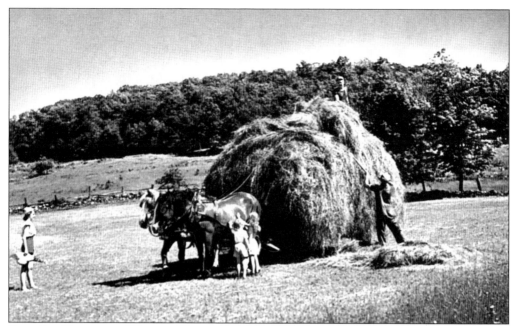

THE OLD-FASHIONED WAY TO HAY. Not a staged photograph, this was actually how Luther Barrett, fourth-generation owner of High Breeze Farm, still gathered hay in the late 1950s. Much preferring horses to tractors, Luther's traditional ways gave the farm the Currier & Ives atmosphere it retains. This postcard view was taken by Highland Lakes resident Bucky McDonnell, the "photo poet," and published in 1960. (Author's collection.)

PRICE'S SWITCH: THE PRICE HOMESTEAD. Located at the intersection of Route 94 and Price's Switch Road, the Grant Price Homestead has long been a landmark in northern Vernon. Price's Switch was the nearby railroad switch and track siding on the Lehigh & Hudson River Railroad. The land immediately behind the homestead is now Heaven Hill Farm. (Courtesy Marcela T. Gross.)

17

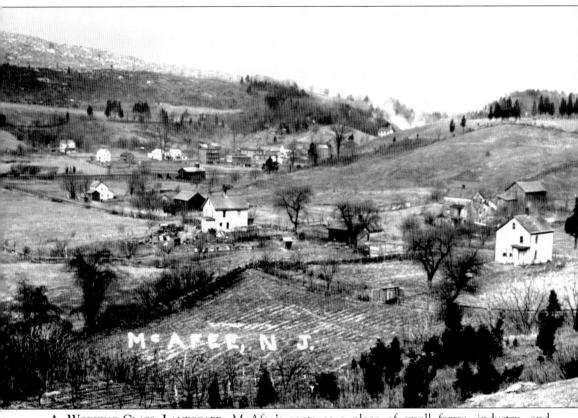

A WORKING-CLASS LANDSCAPE. McAfee's roots as a place of small farms, industry, and commerce is evident in this late-winter view of Old Rudetown Road as seen from Rudetown Road, with the hamlet of McAfee and present-day Route 94 in the distance beyond the railroad tracks. This photograph was taken *c.* 1906 by A.J. Bloom and printed from the original glass-plate negative. (Courtesy the Antique Photo Store.)

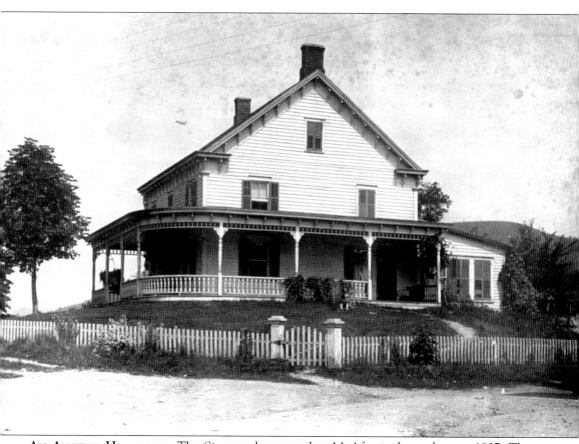

AN ANCIENT HOMESTEAD. The Simpson homestead at McAfee is shown here *c.* 1907. The Simpson family had lived at this site since 1760, and though the house looks very Victorian here, its oldest portion may have been Colonial. Family tradition relates that while standing on the porch of the homestead at the end of the Revolutionary War, the Simpsons watched Gen. George Washington ride through McAfee Valley. The house stood on Route 94 where the McAfee Fire Department parking lot now is and was razed *c.* 1959. (Courtesy Vernon Township Historical Society.)

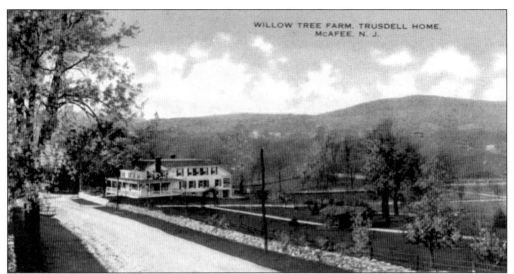

A Graceful Landmark. The Stewart house, on the corner of Route 94 and Sand Hill Road, is said to have been a tavern in the late 1700s. From 1873 to 1981, it was owned by the Campbell-Trusdell-Stewart family and was noted for its beautiful landscaping and manicured grounds. At the time of this *c.* 1915 photograph, it was called Willow Tree Farm. Now owned by Mountain Creek, it has recently been restored to its former charm. (Courtesy Wayne T. McCabe.)

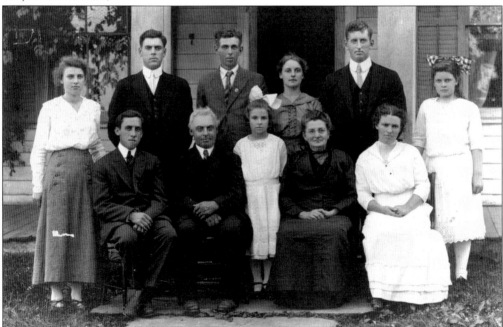

A Venerable Family. Only a few families have had as long and prominent a role in Vernon's history as the Drew family. Gilbert Drew came here *c.* 1790 and raised 12 children. His great-grandson, Theodore Drew Sr. is seated, second man from the left. With him are, from left to right, the following: (front row) Irving Drew, Ardelia Drew, Julia Riggs Drew, and Sarah Drew Marsh; (back row) Margery Drew Van Orden, Leon Judson Drew, Theodore Drew Jr., Ethel Drew Wallace, Marion Riggs Drew, and Ina Drew. (Courtesy Catherine Drew.)

A LOST LANDMARK TAVERN. The Ed Snook farm is shown here in the late 1960s. Snook provided busing for the Vernon schools, as evidenced by the school buses parked in front. The farm was located on Route 94 opposite present-day Great Gorge Village and the Spa at Crystal Springs. The house (right) was built in 1790 as a tavern by Simon Simonson; it was said to be the second-oldest tavern in Vernon, after Winans tavern. Simon Simonson operated it as a tavern through the War of 1812. In later years, it was passed to T.T. Simonson. As can be seen, it remained a substantial dairy farm through much of the 20th century. The land was ultimately purchased by the Playboy Hotel for part of its golf course and for horseback riding. Playboy had no interest in preserving the 180-year-old structure, and Simonson's Tavern, sadly, was set afire and burned down for a fire department exercise drill in 1970. Only the concrete steps that led from the road to its front door survive. The round-roofed barn also survives, and is currently the Legends Hotel horseback riding stables. (Courtesy Peg and Jack Kurlander.)

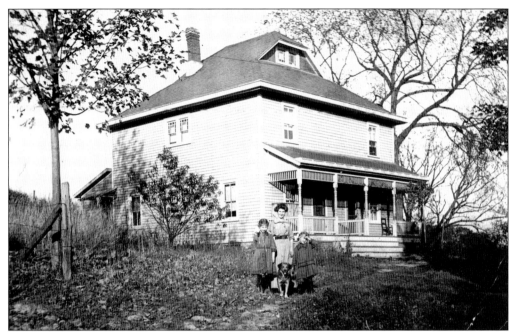

A DUPLEX HOUSE, GLENWOOD. With its stylish hipped-gable attic dormer and attractive spindle-work porch, this duplex tenant house was built c. 1900 in Glenwood. Shown in front is the Monks family (with Prince the dog) minus father Frank, who was right-hand man to Capt. Daniel Bailey. The house still stands on Route 565. (Courtesy Ethel Van Duzer and Dorothy Ji.)

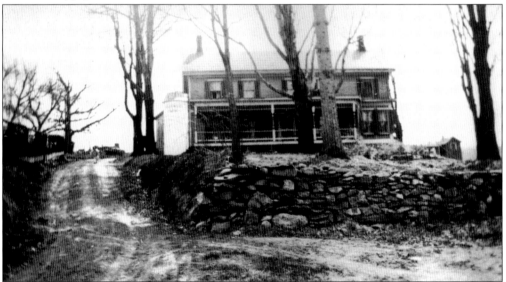

NOT A HOLLYWOOD ENDING. The Hollywood Farm in Glenwood met its demise in January 1956, when the tenants' son disposed of a bucket of hot ashes in a basket on the back porch. The house was gutted by fire, but the white silo, to the left rear of the house, survived and currently bears the image of the Vernon Viking; the site is now the entrance to Vernon Township High School. (Courtesy Vernon Township Historical Society and Beatrice Potter Masker.)

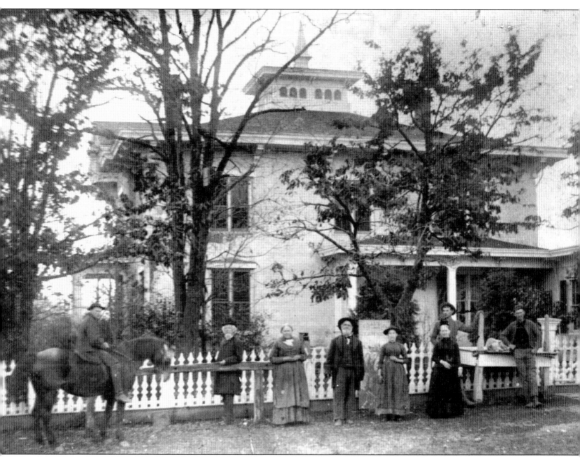

A House the Gold Rush Built. The Peter J. Brown house stood on the sharp bend of Route 517 near Glenwood (recently straightened, now Old Glenwood Circle). Peter J. Brown made his fortune in the Gold Rush of 1849—not panning for gold, but selling supplies to those who did from his store in Sacramento, California. Returning to New Jersey, he built this Italianate-style mansion in 1853. In this *c.* 1885 photograph, Brown, in the center with a full white beard and hat, stands beside a door on which is painted "I LIVE IN JERSEY." Just below is a full-length portrait of a confident, well-dressed gent. On the reverse is "I LIVE IN YORK," and the fellow portrayed is a comical, tattered hayseed. The door was from a Vernon tavern (possibly Winans) of the 1700s, a relic of the border war days, when New York-New Jersey animosities ran high. This piece of Colonial folk art (and political caricature) later left the Brown family and is today on display at the New Jersey Agricultural Museum at Rutgers. The Brown house enjoyed no such happy fate: it burned down in 1971. (Courtesy Ethel Van Duzer and Dorothy Ji.)

A GLENWOOD CORNER SCENE, C. 1915. These barns on the corner of Routes 517 and 565 in Glenwood, opposite Pochuck Valley Farms, have been landmarks for most of the last century. The property was originally part of the Gabriel Houston farm and was purchased by Lewis Ryerson Martin in 1912, who also purchased the former Houston homestead, now Apple Valley Inn. Such barns are an increasingly vanishing part of our landscape. (Courtesy Wayne T. McCabe.)

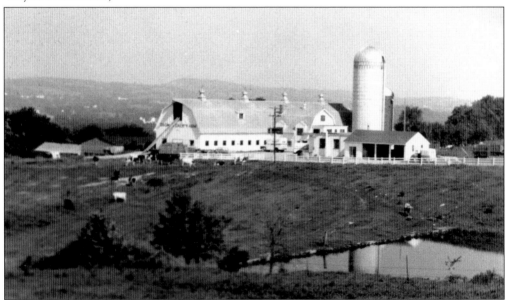

DAGMAR DALE FARM. In 1954, Gustav and Dagmar Nyselius bought the old Lewis Dunn farm on present-day Route 565 near Independence Corners, and it became Dagmar Dale Farms, the last in Vernon to produce, bottle, and distribute its own milk. It was later owned by the Van Althius family. The classic dairy barn seen here burned in 1996, but the nearby c. 1850 house survives and is headquarters of the Wallkill River National Wildlife Refuge. (Courtesy Marcela T. Gross.)

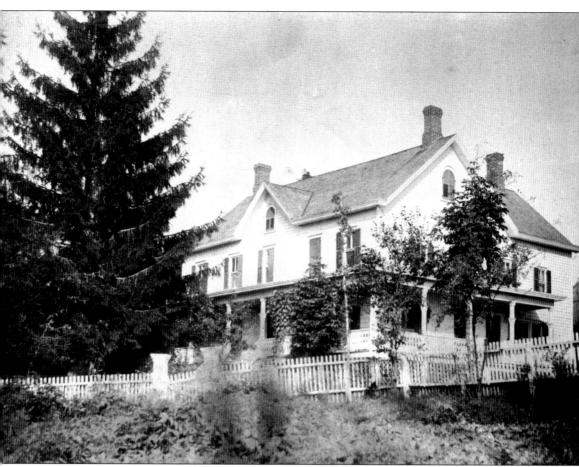

THE PRIDE OF GLENWOOD. The Capt. Daniel Bailey homestead, shown here c. 1885, stood at the corner of Route 565 and Armstrong Drive. The house was built in the mid-1800s, but its oldest portions were said to date to the Colonial period. Daniel Bailey was born here and lived here until his death in 1923. For many generations, it was one of the most prominent and beautiful homes in Glenwood. In 1985, it suffered a major fire and was torn down a year later. (Courtesy Marcela T. Gross.)

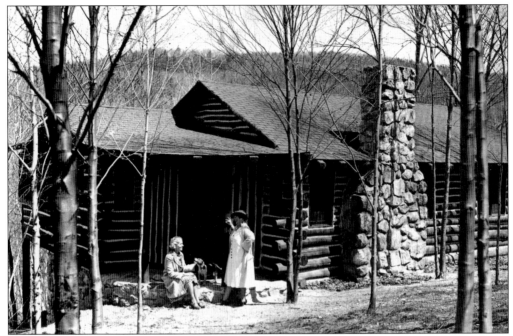

LOG CABINS—AGAIN. Log house construction, common in Vernon in the 1800s, became popular once again in the 1920s and 1930s, when summer lake communities such as Lake Wallkill and Highland Lakes reintroduced them as summer cottages. In spite of their rustic flavor, they bore little resemblance to the log houses of the early settlers. This c. 1938 photograph shows two women and their dog inspecting their recently completed summer home at Highland Lakes. (Courtesy Highland Lakes Country Club.)

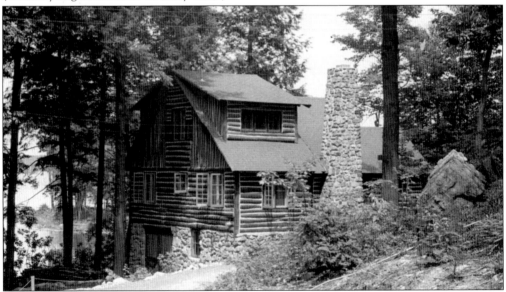

A LAKESIDE CABIN IN THE HEMLOCKS. This large cabin on Lakeside Drive West in Highland Lakes exhibits many common features of 1930s summer cabins, including shed dormers in the roof, vertical log gables, and a massive rustic stone chimney. Shown here c. 1938, the house looks much the same today. (Courtesy Highland Lakes Country Club.)

26

Two

STORES, TAVERNS, AND BUSINESSES

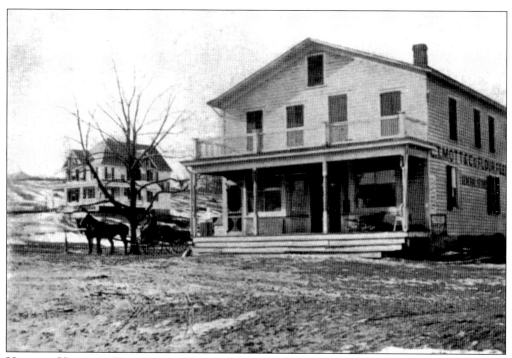

VERNON VILLAGE: THE LOWER DECK. After the Lehigh & Hudson River Railroad came through Vernon in 1881, a collection of businesses grew up around its depot at Vernon Crossing Road, including the general store of Charles T. Mott (right) and nearby Sunset View (left), a small hotel built by the Motts, shown *c.* 1905. Located below the main part of Vernon village, the area came to be called the Lower Deck. (Courtesy Wayne T. McCabe.)

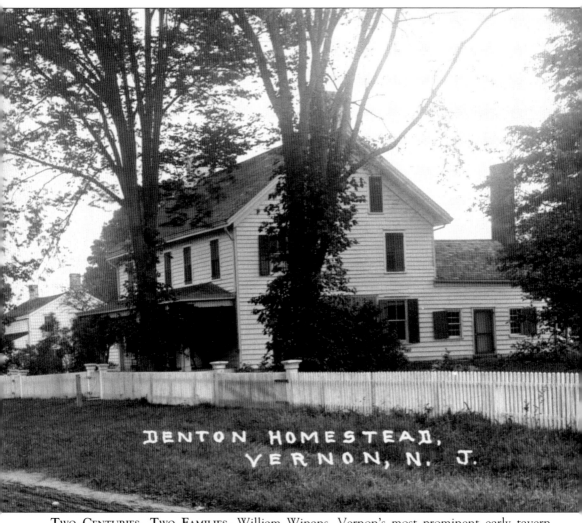

DENTON HOMESTEAD,
VERNON, N. J.

TWO CENTURIES, TWO FAMILIES. William Winans, Vernon's most prominent early tavern keeper, was operating this tavern at the present-day intersection of Routes 94 and 515 by the early 1780s. The only tavern between Hamburg and Warwick at the time, it was naturally a popular operation. Several army officers in the Revolutionary War made note of stopping here. Winans enlarged the tavern c. 1802 but in later years gave up tavern keeping and simply used it as a home. In 1827, the place was purchased by the Denton family, who also used it as a home; in later years it was passed to their descendants, the Uptegrove and Ztanze families. It stayed in the same family from 1827 until the 1990s, when its contents were auctioned off, and the venerable building and property were sold. It was replaced by Burger King in 1999. (Courtesy the Antique Photo Store.)

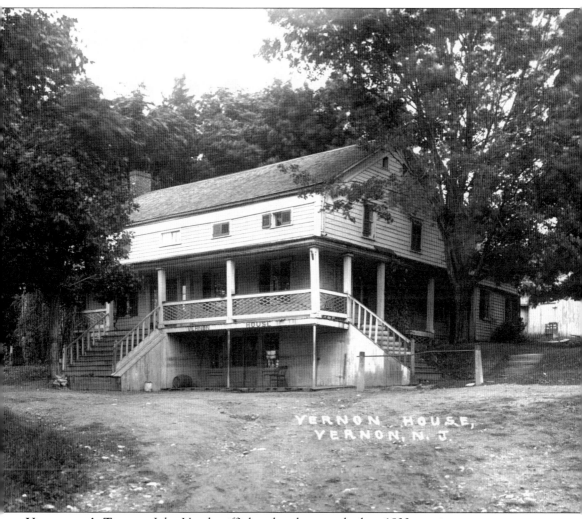

VANDEGRIFF'S TAVERN. John Vandegriff's hotel and tavern, built *c.* 1833, was in many respects the successor to William Winans's tavern as the main public house in Vernon village. John Vandegriff was one of Vernon's most durable tavern keepers and was licensed to keep tavern at various times between 1815 and 1858. During most of this era, from the early 1830s through the late 1850s, he kept tavern at Vandegriff's Hotel. From the 1880s through the 1920s, it was the Vernon Hotel, owned by Joseph Burrows. It is shown here *c.* 1907 in an A.J. Bloom photograph. In later years, quite changed, it became the well-known Gary's Vernon Lodge on Route 94. For many years in the 19th and early 20th centuries, this famous tavern was the meeting place for the Vernon Township Committee, and an almost countless array of other public meetings, sheriffs sales, and assemblies were held there. It is a true Vernon landmark, and it has a long and interesting history. (Courtesy the Antique Photo Store.)

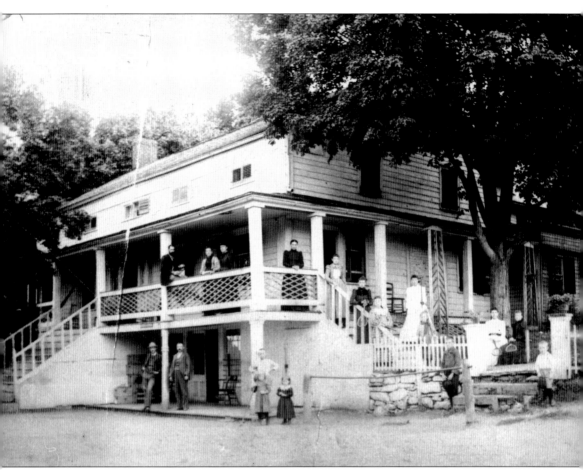

THE VENERABLE VERNON HOTEL. Burrow's Vernon Hotel, originally owned by John Vandegriff, is shown here with Joe Burrows and his family and friends *c.* 1895. During all that time, it was Vernon's de facto place to meet, and it was a popular hotel for those stopping in Vernon. One of the hotel's notable guests was archaeologist Max Schrabisch, who conducted the first survey of Native American sites in Sussex County. In addition to being an innkeeper, Burrows owned more than 1,000 acres on Wawayanda Mountain and was engaged in an extensive lumber trade. For a time, he supplied the Lehigh & Hudson River Railroad with all their track ties. (Courtesy Vernon Township Historical Society and Jeannette and Elizabeth Birkland.)

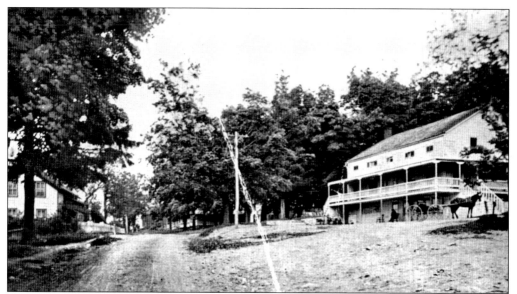

THE PLACE TO MEET. Few public houses were more frequented than Burrow's Vernon Hotel (right). The hotel register, with entries from 1886 to 1926, is owned by the Vernon Township Historical Society. This c. 1914 postcard refers to the grove of trees adjacent to the hotel as the "park." Across the street from the hotel is Herman Yanzer's barbershop and home (see page 10). (Courtesy Vernon Township Historical Society.)

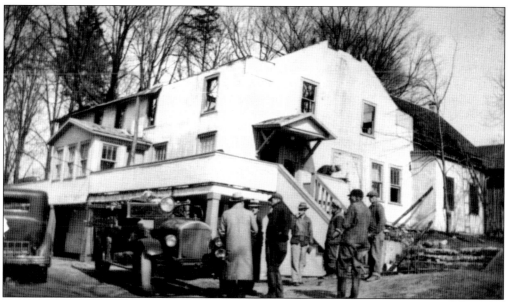

TIME TO REBUILD. One chilly night in April 1936, Mrs. Raymond Leeper went to the attic of the Vernon Hotel, then owned by her husband, to fetch a blanket. As she set her kerosene lamp on the floor, a squirrel jumped out of the blanket chest and knocked the lamp over. The results are seen in this photograph. The hotel was extensively rebuilt. (Author's collection, courtesy Elizabeth Wallace LaBar.)

HORSESHOES AND CARBURETORS. Built *c.* 1910 out of handsome cast-cement blocks, the garage and blacksmith shop in Glenwood dealt with repairing transportation of both the four-legged and the four-wheeled type. The sturdy building, shown here *c.* 1914, still stands on Route 565 in Glenwood and is now a home. (Courtesy Marcela T. Gross.)

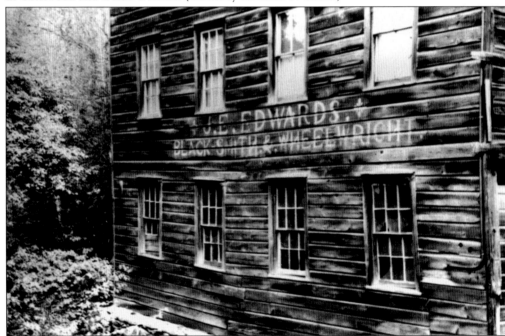

AN EMPTY RELIC. The two-story shop of blacksmith and wheelwright J.E. Edwards in Glenwood survived long after Edwards and his trade had vanished from the scene. It stood alongside the creek near the entrance to Vernon Township High School. For decades it was an empty and abandoned relic, still proudly advertising its long-gone owner and his vanished trade, but it came down in a heap one day in the late 1970s. (Courtesy Vernon Township Historical Society.)

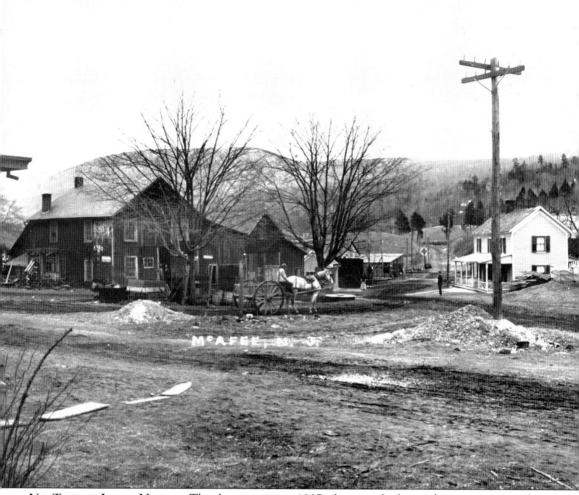

No Traffic Light Needed. This late winter *c.* 1907 photograph shows the intersection of present-day Routes 94 and 517 at the traffic light in McAfee. The blacksmith shop in the left center of the photograph stood on the corner and was later replaced by the McAfee Union Bible Church (for decades thereafter, its founding members recalled the massive effort required to clear the site of scrap iron). Everything else in this view (except Hamburg Mountain in the distance) has likewise been effaced by time. Note the utility pole in the center—not used for electricity, which would not come for many years, but for telephone service, which McAfee enjoyed by 1902. This photograph was printed from the original A.J. Bloom glass-plate negative. (Courtesy the Antique Photo Store.)

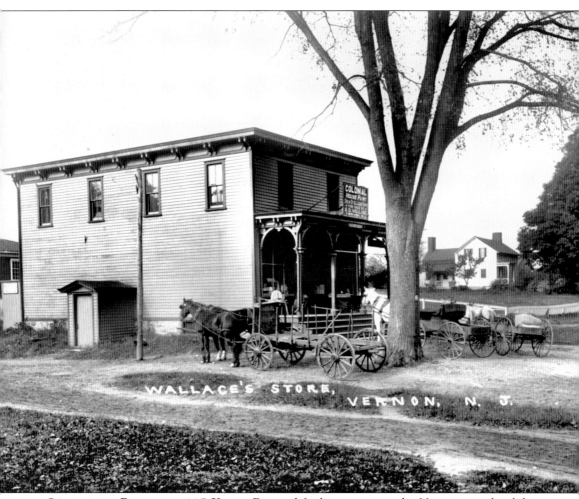

SERVING THE PUBLIC FOR 117 YEARS. Few and far between were the Vernonites who did not have occasion to stop in at this store in Vernon village in the years between the 1880s and the 1960s. It was the place to go for groceries, dry goods, general merchandise, newspapers, mail (it was the Vernon Post Office), and gossip. Solomon S. Denton built it on the corner of present-day Routes 94 and 515 in 1885 (the family had operated a store on the site since the 1820s). It later was operated by Denton's nephew Richard D. Wallace, as seen in this *c.* 1907 A.J. Bloom photograph. It served the public there until 1966, when it was moved to Church Street, and a Mobil gasoline station was built in its place. In its second home, it still serves the public as the Mixing Bowl Restaurant. The store signs in this photograph advertise Wrigley's Chewing Gum, R & G Corsets, and Colonial House Paint, the "Cream of All Liquid Paints." (Courtesy the Antique Photo Store.)

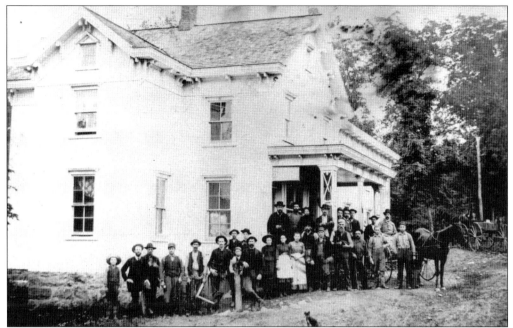

THE WHOLE DARN NEIGHBORHOOD. Capt. Daniel Bailey of Glenwood (with a beard, wearing a black hat and jacket on porch) was joined by friends, employees, carpenters, and miscellaneous others in this photograph of his Glenwood General Store. The photograph was likely taken in 1883 to mark the completion of a major expansion of the store. The store included a Western Union telegraph office, the lines of which are visible in front. (Author's collection, courtesy the Kopec family.)

CAPTAIN BAILEY'S LEGACY. Among the many other hats he wore, Daniel Bailey was Glenwood postmaster from 1877 to 1886. The Glenwood Post Office was located here in his general store, and it stayed there long after he was gone—until 1975, in fact. For many years, Grover Smith was postmaster and operator of the store. The building still stands on Route 565, somewhat altered. (Author's collection, courtesy Ethel Van Duzer.)

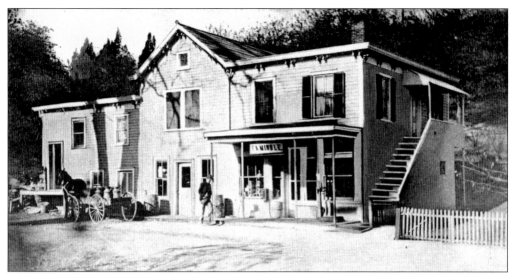

THE MCAFEE VALLEY POST OFFICE. For most of the 20th century (until the 1980s), this was McAfee's post office. As shown here *c.* 1907, it was also the general store of Frank A. Mingle, who published numerous McAfee postcards (including this one, not surprisingly). The building still stands, opposite the George Inn parking lot. (Courtesy Marcela T. Gross.)

STILL THERE, BUT MUCH CHANGED. McDanolds Brothers Company general store on present-day Route 94 in McAfee is shown *c.* 1905. Built in the late 1800s and later operated by Leon C. "L.C." Ruban, the store has been remodeled and its roof design changed, almost wholly altering its appearance. It is now the original, older portion of the McAfee Firehouse. (Courtesy Wayne T. McCabe.)

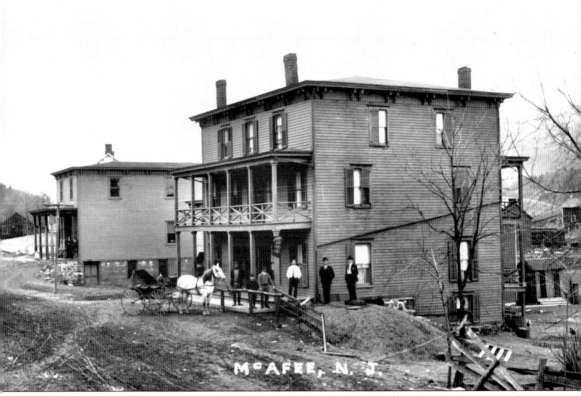

McAfee's Famed Hostelry. William Simpson built this McAfee hotel in 1873, soon after the railroad reached the town. The hotel and tavern were later owned by Leon C. Ruban, who called the building the Sussex Hotel, even though it mainly served a McAfee clientele. It was later operated by the Conklin and Hovencamp families. Substantially rebuilt after a 1935 fire, its flat roof was converted to a gable-end roof. It has undergone multiple ownerships, at least one additional fire, and several phases of reconstruction, remodeling, and expansion. Rear additions both in the past and in 2002 have greatly enlarged it, so that little remains of its historical appearance. It is currently the George Inn on Route 94. It is shown here *c.* 1906, when it was owned by Ora C. Simpson (son of builder William), who was Sussex County clerk at the time. This photograph was printed from A.J. Bloom's original glass-plate negative. (Courtesy the Antique Photo Store.)

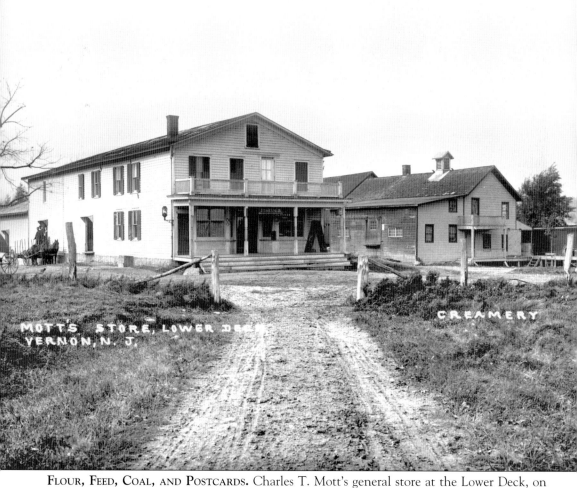

FLOUR, FEED, COAL, AND POSTCARDS. Charles T. Mott's general store at the Lower Deck, on Vernon Crossing Road near the railroad tracks, is shown in this *c.* 1906 A.J. Bloom photograph. Prominent in a variety of Vernon civic and business affairs, Charles Mott was also an innkeeper and constable. He used this and other Bloom photographs in a postcard series he published at the time. This view was on the cover of an accordion foldout postcard with photographs of many other Vernon village landmarks. The store later burned, as did the adjacent creamery. Today, the concrete ruins of a later creamery mark the location of the first creamery, opposite Place By The Tracks deli. Where this store stood, only trees and brush now grow. (Courtesy the Antique Photo Store.)

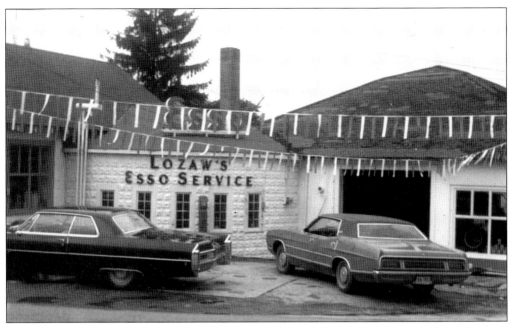

VERNON'S FIRST GAS STATION. Oscar Lozaw built his Vernon Esso station in 1924 on the corner of Routes 94 and 515. It specialized in automobiles only—no horses! Lozaw was also Vernon's justice of the peace from the early 1930s until 1972. Lozaw's Esso station is seen here in 1971. Long a Vernon landmark, it was torn down and replaced by a new auto repair center *c.* 1980. (Photograph by Roswell S. Coles, courtesy Vernon Township Historical Society.)

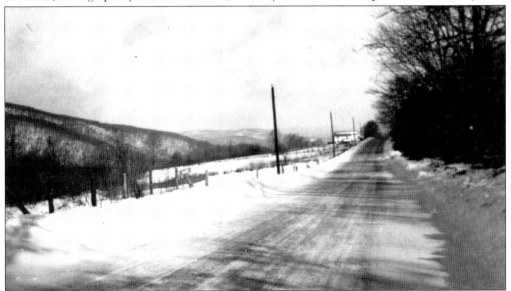

CONWAY'S STORE: WELCOME TO VERNON. Entering Vernon from the south, the first view of the Vernon valley is on Route 515 near the present Lake Conway development. In this view from the winter of 1944, before Lake Conway was built, is Conway's Store (later the Perch restaurant) at the intersection with Highland Lakes Road. Members of the Conway family recall that as children in these distant winter days, they could toboggan down Sisco Hill all the way to Vernon. (Courtesy Lois Scordato.)

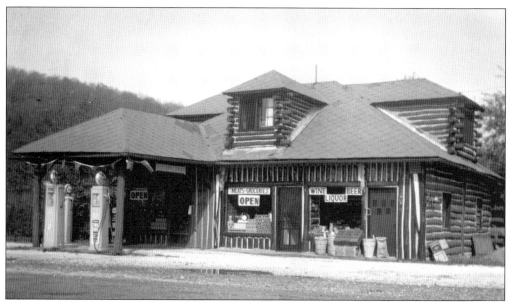

"AT THE ENTRANCE TO HIGHLAND LAKES." In 1938, McAfee tavern keeper Lester W. Jennings hoped to build a tavern at the entrance to the new summer development, Highland Lakes. Township officials denied that request but granted him a retail liquor license, and he built the Highland General Store. The store was built in the same rustic log style as the rest of Highland Lakes. (Courtesy Ron and Phyllis Dupont.)

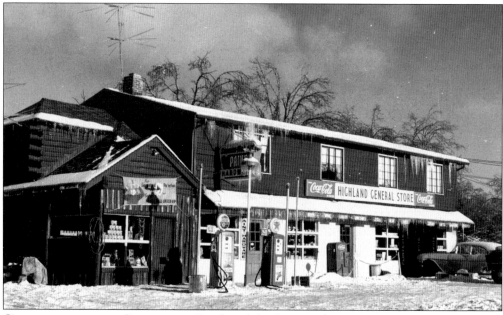

GROWING WITH THE COMMUNITY. Purchased by Jane and Herman Dupont in 1953, the Highland General Store grew along with Highland Lakes. The store is shown here in the winter of 1958. Note the large tarpaper patch covering the hole where a customer had just driven through the front wall. The business is in the same family 50 years later, although a certain member has been known to fribble away time on local history. (Courtesy Ron and Phyllis Dupont.)

Three

SCHOOLHOUSES AND STUDENTS

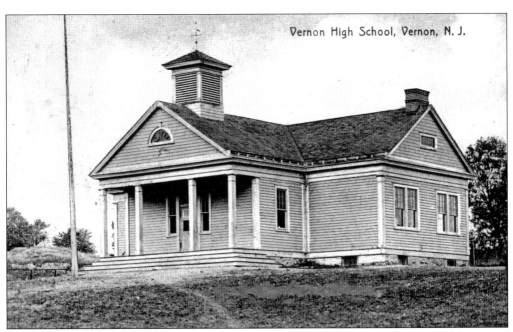

MANY ROLES DURING A CENTURY. The two-room Vernon School, seen here *c.* 1905, opened in March 1903. Designed by local architect Thomas W. DeKay (1865–1937), a descendant of Vernon's first Colonial settler, the school (never literally the high school) operated until 1958. Converted to the town hall and library, it served that role until 1978, when the present municipal center opened, and it took on its current role as board of education headquarters. (Courtesy Vernon Township Historical Society.)

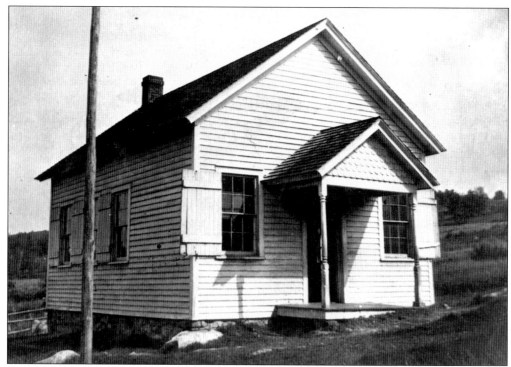

DISAPPEARED WITH THE COMMUNITY IT SERVED. Over the years, from the early 1800s to 1913, there were three different schools at Canistear, this one being the last. It stood on the east side of Canistear Road opposite the reservoir. Moved to this site in 1898 due to construction of the reservoir, it closed in 1909, as the population of the area decreased to nil, and was auctioned off for scrap in 1913. (Courtesy Jennie E. Sweetman.)

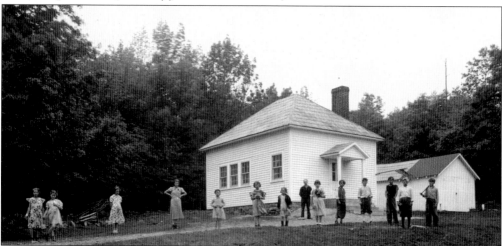

THE HIGHEST SCHOOLHOUSE IN NEW JERSEY. The Parker School, whose elevation was highest of any in the state, stood on Breakneck Road, diagonally opposite the Highland Lakes Clubhouse property. Built in 1820, it was remodeled in 1906 and finally closed in 1946. The historic 126-year-old school was then torn down and replaced by a new house that, ironically, was later purchased by the future founders of the Vernon Township Historical Society, Pearl and Roswell S. Coles. (Courtesy Marcela T. Gross.)

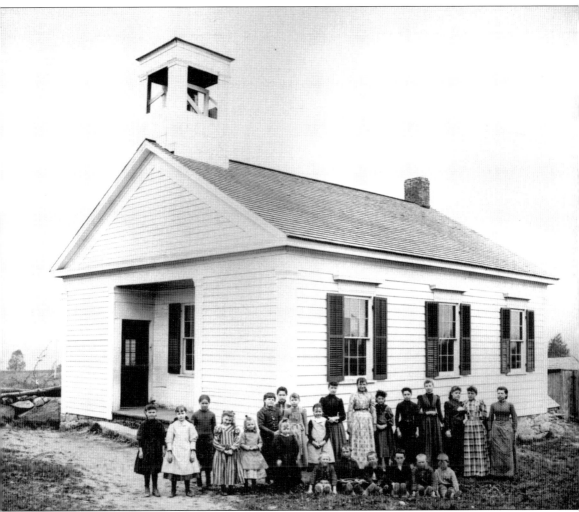

TEMPLE OF EDUCATION. The Vernon School, shown here *c.* 1890, stood in the present parking lot of the Vernon United Methodist Church on the corner of Church Street and Route 94. Built in 1850, it replaced an earlier school and served the pupils of Vernon village until 1903. At that time, a move toward school consolidation led to the construction of a new two-room school in the hamlet (see page 41), which replaced both this school and the Longwell School. Architecturally, this school represents a somewhat better-than-average mid-19th-century rural New Jersey schoolhouse, with mildly Greek Revival-flavor architecture. Note the well-worn path to the privy in the rear. (Courtesy Vernon Township Historical Society and Dorothy and Steven Ztanze.)

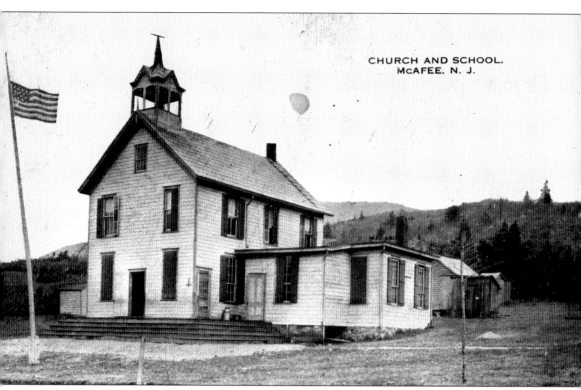

THE SCHOOL ON THE HILL. The McAfee School, built in 1878, was located on the west side of Route 517 just south of the Legends Hotel entrance. A school was first built there *c.* 1838. By the 1870s, it was dilapidated and was replaced by this two-story school with an ornate belfry, which was regarded at the time as a model example of modern school design. It operated there until 1908, when smoke, noise, blasting, and the occasional flying rock from the nearby limestone quarry and kilns required the moving of the school building to a safer location. It was relocated by the quarry operator, Bethlehem Steel, to a spot on present-day Rudetown Road near the intersection with Route 94, just east of McAfee, shown in this postcard. In both locations the school's upper level doubled as a church on Sundays, as McAfee had no regular church. It stood at its second location until 1921, when it was torn down and replaced by a new school. (Courtesy Marcela T. Gross.)

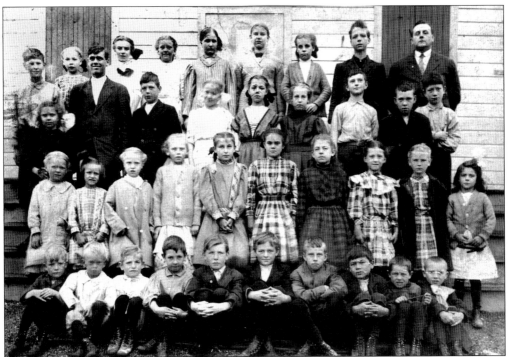

ONE TEACHER, 37 STUDENTS. The larger-than-average McAfee School Class of 1911 is shown here with teacher George C. Smith (upper right corner). Teaching such large groups of students of such varying ages was always a challenge for teachers in rural schools. Smith was up to the task, however, and he taught at McAfee from 1907 until his death in 1939. (Courtesy Vernon Township Historical Society.)

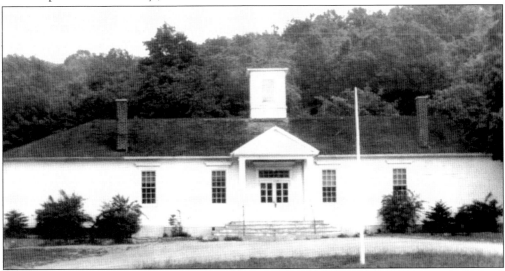

A NEW SCHOOL FOR McAFEE. This modern school replaced the old two-story McAfee School in 1921. It closed in 1958 and was auctioned off by the board of education. In 1962, the building became St. Francis de Sales Church, a role it served for nearly 25 years, until the present St. Francis de Sales Church was dedicated in 1986. The building still stands. (Courtesy Vernon Township Historical Society and Vernon Township Board of Education.)

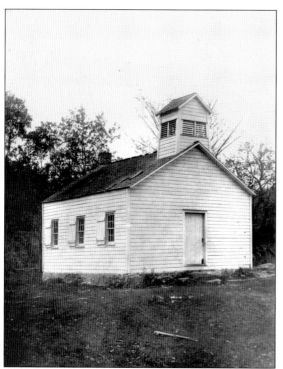

SOON TO VANISH. The Williams (also known as Williamsville) School was built *c.* 1840. It stood on the present-day Route 515 in the Pequannock Watershed, near the headwaters of the Pequannock River. The only public building in this sparsely settled area, it doubled as a church on Sundays and as an occasional meeting place of the Vernon Town Council. Here, the school is seen *c.* 1903 in an A.J. Bloom photograph. (Courtesy Vernon Township Historical Society.)

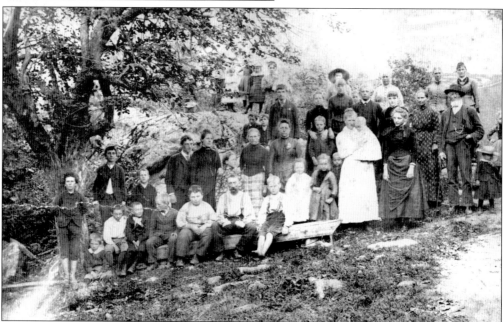

A SCHOOL PICNIC AT WILLIAMSVILLE, C. 1896. The students of Williams School pose with their teacher, Lizzie A. Farber, and miscellaneous other family members in this photograph by local photographer J. Percy "Camera" Crayon of Newfoundland. In addition to photography, Crayon was a notable local genealogist and historian, sold sewing machines and pump organs, was an insurance agent, and dealt in books, magazines, and newspapers. (Courtesy Vernon Township Historical Society.)

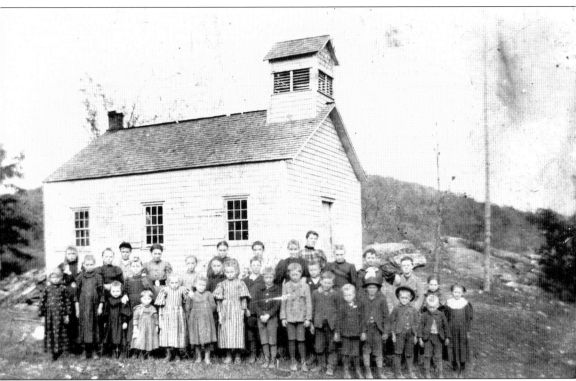

A WILLIAMSVILLE SCHOOL CLASS PHOTOGRAPH, C. 1896. The teacher in this photograph, Lizzie A. Farber, taught at the Williamsville School from 1895 to 1897. Note that the design and construction of this mountain district school was simpler and more austere than that of village schools in the valley, which were usually better funded. It had a belfry, however, though the bell was stolen in the school's final years, a mystery for decades thereafter among local folk. In use for some 60 years at this point in its career, the Williamsville School was closed in 1909, after most of the surrounding farms had been bought by the city of Newark for its watershed. The school was auctioned off for scrap lumber, and only the traces of its foundation now mark the site. (Courtesy Vernon Township Historical Society.)

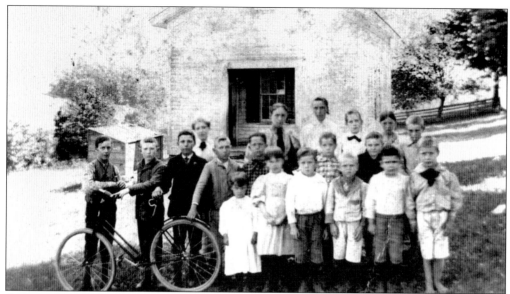

A CENTURY OF SERVICE. There were four different schools in Glenwood between 1795 and 1958, this being the last one, built in 1864 on the corner of present-day Route 565 and Glenwood Mountain Road. In this *c.* 1900 class photograph, note that one student was sufficiently proud of his bicycle—then a newfangled rarity—to want to include it in the picture. (Courtesy Vernon Township Historical Society.)

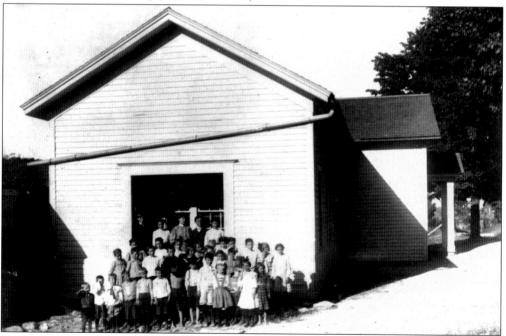

FROM ONE ROOM TO TWO ROOMS. In 1906, as part of a broader plan of school expansion and modernization in Sussex County, the Glenwood School was expanded from one room to two rooms. This created an L-shaped structure, as seen in this *c.* 1907 class photograph. The reason for the enlargement is evident: almost double the enrollment of a few years before. (Courtesy Vernon Township Historical Society.)

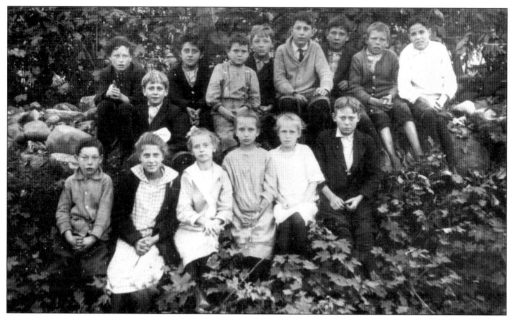

THE SCHOLARS OF GLENWOOD, 1912. Glenwood School pupils pose for their 1912 class photograph. The boy sitting on the right in the front row is Howard Masker, who became teacher and later principal of the same school from 1925 to 1958. His wife, Bea Masker, later noted that Howard and the other boy in the front row, Harold Romaine, both look somewhat annoyed because they objected to being made to sit in the front row with the girls. (Courtesy Vernon Township Historical Society and Beatrice Masker.)

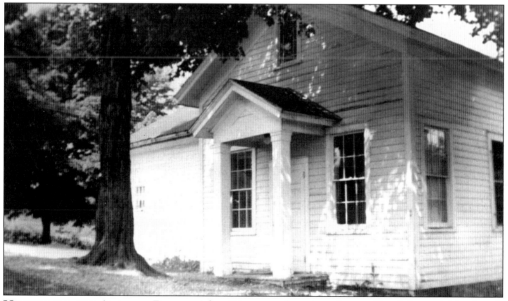

HEADED FOR THE AUCTION BLOCK. After 94 years educating the pupils of the neighborhood, the Glenwood School was closed in 1958, and its enrollment was sent to the new Vernon Consolidated School (now known as Walnut Ridge). The old school was sold at auction for $2,300 to a man who converted it to a dwelling. Still in use as a home, it stands near the Appalachian Trail, looking much the same today. (Author's collection.)

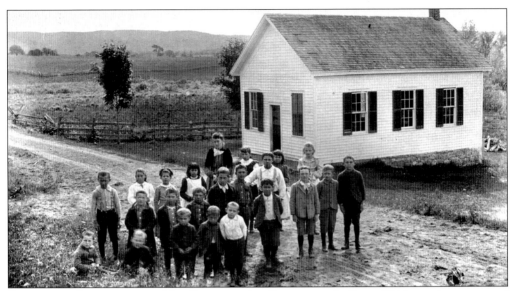

EDUCATING SPRAGUETOWN. The Sprague schoolhouse was built *c.* 1840 on the corner of present-day Route 517 and Drew Mountain Road. After some 60 years of service, it was deemed unsafe, and in 1903, it was replaced by a new schoolhouse just up the road. The old school was converted to a tenant house on the Irving Drew farm and burned in 1936. (Courtesy Catherine Drew.)

IN BLACK DIRT COUNTRY. The Milton, or Owens, School operated near the intersection of Lake Wallkill and Owens Station Roads. There were two schools here over the years. The first was used from *c.* 1860 to 1934. The second, shown here, was built near the first in 1934 but featured more classrooms and modern amenities. In 1958, it was auctioned off with Vernon's other local schools. Today it is a dwelling. (Courtesy Vernon Township Historical Society and Vernon Township Board of Education.)

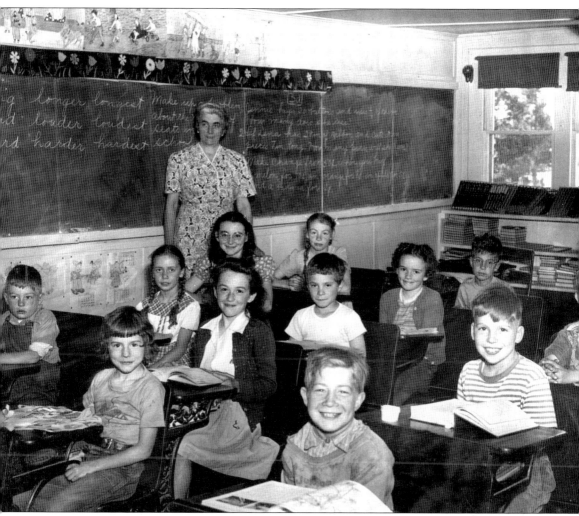

SAY CHEESE! The Price's School Class of 1948 is shown here with Matilda Price, the teacher. Her husband, Grant Price, was born nearby, and his family gave their name to the school and the neighborhood, Price's Switch. The school was originally built *c.* 1840 on present-day Route 94. It was moved to its present location on Price's Switch Road *c.* 1883, and it was enlarged and remodeled twice over the years. By 1900, one-room schools were being closed and consolidated with two- and three-room schools such as those at Vernon, Glenwood, McAfee, and Owens. Due to its relative isolation, however, Price's remained a one-room school until 1958, when all of Vernon's small schools were replaced by the Vernon Consolidated School (now Walnut Ridge). Though it had electricity, Price's School was heated by a coal stove and used outdoor privies until it closed in 1958. Alumni generally agree that though the facilities may have been old-fashioned, the education they received was first-rate. (Courtesy Dan Kadish.)

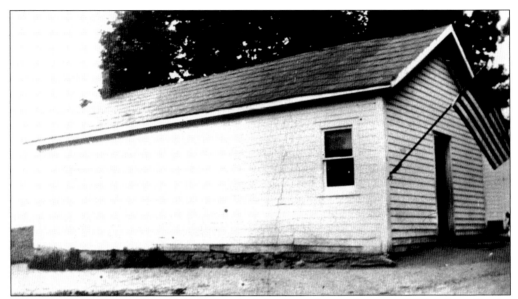

THE LAST OF THE ONE-ROOMERS. Price's School is shown here c. 1937, when Bertha Martin Compton was the teacher. Price's was the last one-room school to operate in Sussex County. Today it is a museum of early education, owned by the Sussex County Board of Chosen Freeholders and operated by the Vernon Township Historical Society. Hundreds of schoolchildren visit Price's School each year to learn about early education. (Courtesy Vernon Township Historical Society and Bertha Martin Compton.)

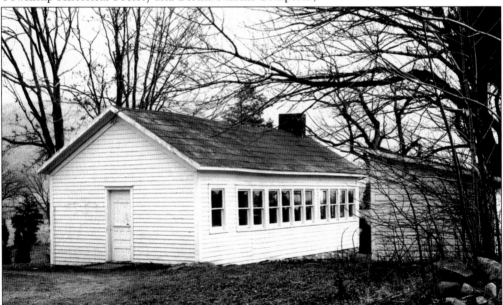

A MODERN SCHOOL, C. 1905. Price's School was considered out-of-date when Ralph Decker became the superintendent of schools in Sussex County in 1902. Decker soon had the building enlarged and remodeled with progressive features such as adjustable seats, boys' and girls' coatrooms, and a solid bank of windows on the left side of the classroom, permitting ample natural light—the school was not electrified until the late 1930s. (Photograph by P. David Horton, Warwick, New York.)

Four

CHURCHES

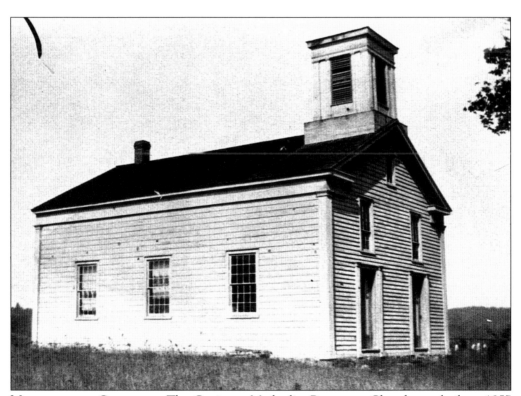

METHODISM AT CANISTEAR. The Canistear Methodist Protestant Church was built *c.* 1857 on land donated by Adam Smith, Esq., immediately adjacent to the Canistear Cemetery on Canistear Road. By 1885, it was in use as a Baptist church. It was likely gone by *c.* 1913, as Newark completed the land buyout of the area for watershed. The Canistear Cemetery is still there, but only the foundations of the church survive. (Courtesy Jennie E. Sweetman.)

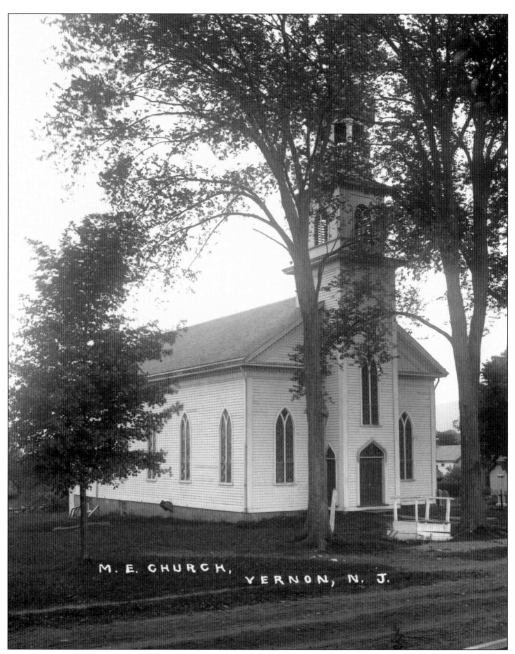

M. E. CHURCH, VERNON, N. J.

As It Once Appeared. The Vernon United Methodist (originally Methodist Episcopal) Church, seen here in a *c.* 1907 A.J. Bloom photograph, has changed over the years. The Methodists acquired the property in 1835 and built the first church on the site in 1837. That church was torn down in 1871, and the present church was built in 1872. It had not much changed by the time of this photograph, but soon would. Its original belfry cupola, shown here amidst the tree branches, blew off in a 1918 hurricane. A side wing designed by John H. Dean was added in 1964, and the front doors and windows were rearranged in 1983. Note the wooden carriage step in front, to help ladies get down from their carriages. This print is from the original glass-plate negative. (Courtesy the Antique Photo Store.)

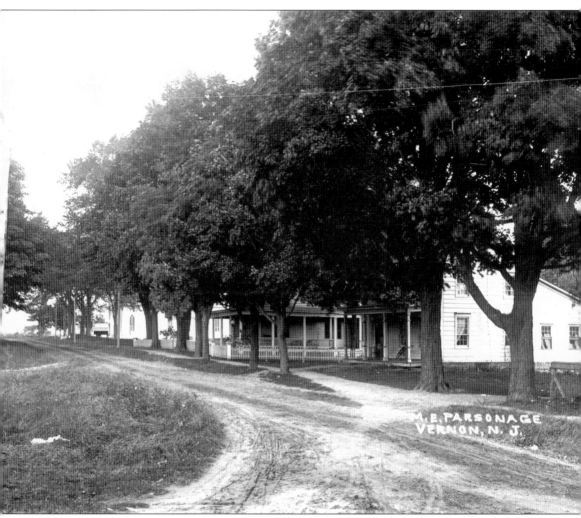

THE OLD METHODIST PARSONAGE AND ROUTE 94. Scarcely recognizable today, this *c.* 1905 scene is Route 94 looking towards Church Street from the intersection of Routes 94 and 515. The Gothic window of the Methodist Church is visible on the left. This bucolic lane suffered the effects of the 20th century—trees were cut to accommodate road paving and widening and utility line poles were put in. The Old Methodist Episcopal Parsonage, on the far right, was demolished for a service station parking lot. The dwelling next to it still stands. The next building down the road would be the old St. Thomas parish house, which is not there because it was not built until 1911. Vernon had no electricity yet, but telephone poles are visible here. This A.J. Bloom photograph, printed from the original glass-plate negative, was published as a postcard. (Courtesy the Antique Photo Store.)

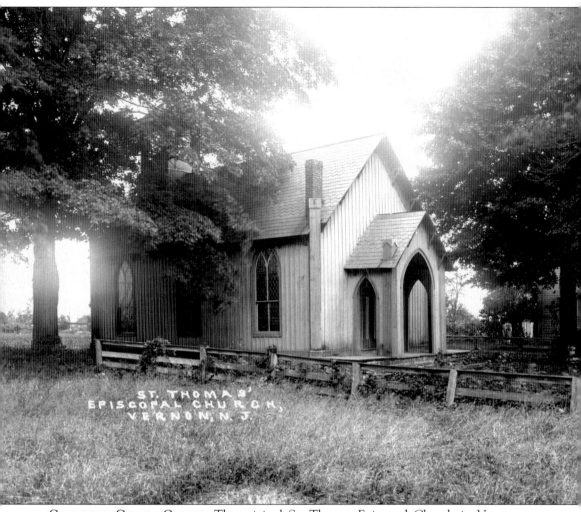

CARPENTER GOTHIC CLASSIC. The original St. Thomas Episcopal Church in Vernon, now known as the Chapel, was constructed in 1847 at a cost of $1,500. The Rutherfurd, DeKay, and McCamley families were among its earliest benefactors. It is the oldest extant church building in Vernon Township and is a celebrated example of the mid-19th century Gothic Revival style, referred to as Carpenter Gothic in such wood-frame structures. The vicarage, to the right, was originally the residence of Dr. Carlos Allen, publisher of the Hopkins 1860 map of Sussex County. Old-timers claimed that the substantial fence around the church was necessary to keep cows from grazing right next to it. This c. 1906 photograph was taken by A.J. Bloom and printed from the original glass-plate negative. (Courtesy the Antique Photo Store.)

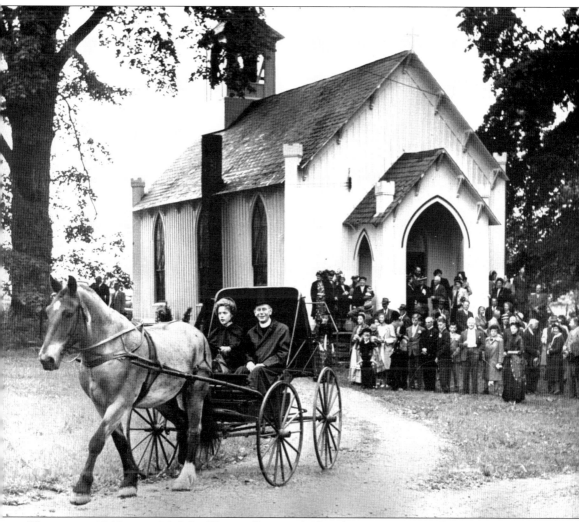

VERNON IN 1948, OR 1848? St. Thomas Episcopal Church was incorporated in 1848, and in this photograph, taken exactly one century later in May 1948, parishioners gather in front of the historic Gothic Revival church to celebrate the centennial. In the horse-drawn carriage are parishioner Julia Lozaw and Bishop Benjamin M. Washburn of the Newark Diocese, who visited to join in the special celebration. The church was closed in 1971 for a decade due to declining membership. Reopened by the diocese in 1981, the Chapel was restored and rededicated in 1983 under Rev. Ray E. Roberts. The new church, now nearby, was designed by the Princeton architectural firm of Short & Ford to emulate the style of the old church. (Courtesy Vernon Township Historical Society and Frank Dewey Garlinghouse.)

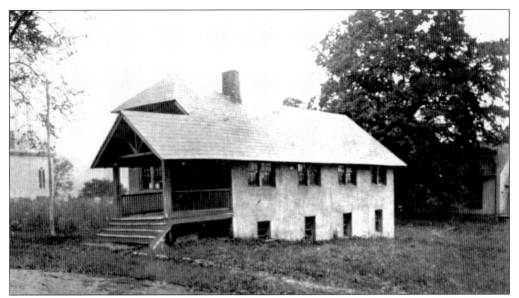

A True Community House. Built in 1911, the original parish house of St. Thomas Episcopal Church served church social functions and a variety of other public roles. It was a temporary school in the 1960s and later served as the town library until 1981. Designed by local architect Thomas W. DeKay, it looks much the same today as Footprints preschool. (Author's collection.)

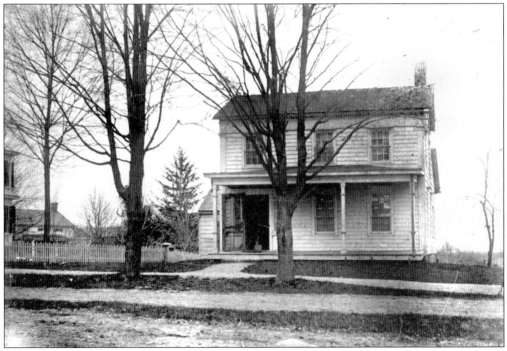

The Old Parsonage. This tidy little home on Route 94 in Vernon village was built by Henry H. Betts in 1846, and from 1901 to 1973, it was the parsonage of the Methodist Episcopal (later United Methodist) church just up the street. It was torn down in 1991, when the adjacent Exxon service station was expanded. (Author's collection, courtesy Elizabeth Wallace LaBar.)

ASHES TO ASHES FOR A BELOVED BUILDING. The elegant, Italianate-style Glenwood Baptist Church was constructed in 1869, replacing a smaller church that was built in 1841. The handsome church was for generations a Glenwood landmark. In a tragic piece of irony, the historic church was consumed by fire on Christmas morning in 1982. The present Baptist church occupies the same site. (Author's collection.)

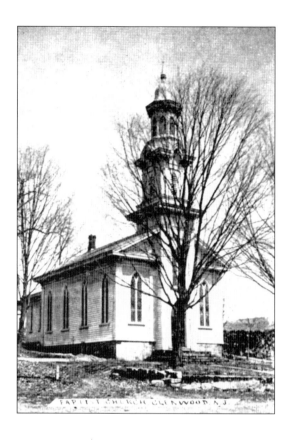

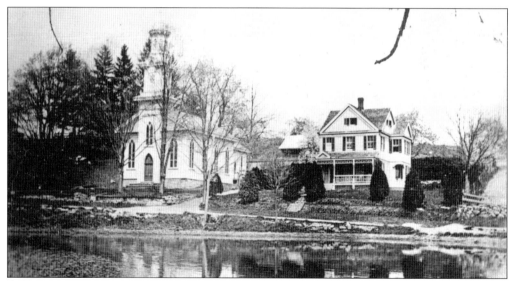

A VIEW ALTERED BY TIME. This charming view of the Glenwood Baptist Church and Parsonage from across the millpond is no longer to be had. The church was destroyed by fire in 1982, and the millpond largely filled with silt from erosion during the 1973–1975 construction of Vernon Township High School upstream. (Courtesy Vernon Township Historical Society.)

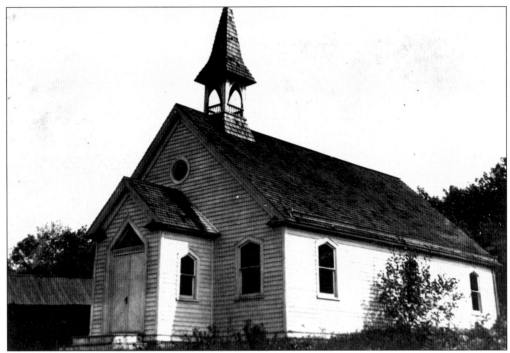

A NEW CHURCH FOR CANISTEAR. In 1878, members of the Methodist Episcopal church built a new church at Canistear. In 1896, the church property was sold for the planned reservoir, and the church bought a new lot of land out of the reservoir's way. The church operated there only until 1913, when it was sold to the city of Newark for watershed, and the building was auctioned off as scrap lumber for $30. (Courtesy Jennie E. Sweetman.)

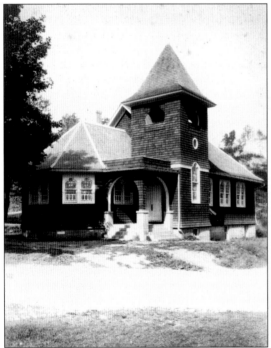

THE LITTLE BROWN CHURCH. The McAfee Union Bible Church, at the intersection of Routes 517 and 94, rose in 1921 on the site of an old blacksmith shop. The congregation formerly met in the old McAfee School, torn down the same year. In 80 years, almost everything else in McAfee has changed, but the neo-Gothic-style McAfee Union Church remains as quaint as ever. (Courtesy Marcela T. Gross.)

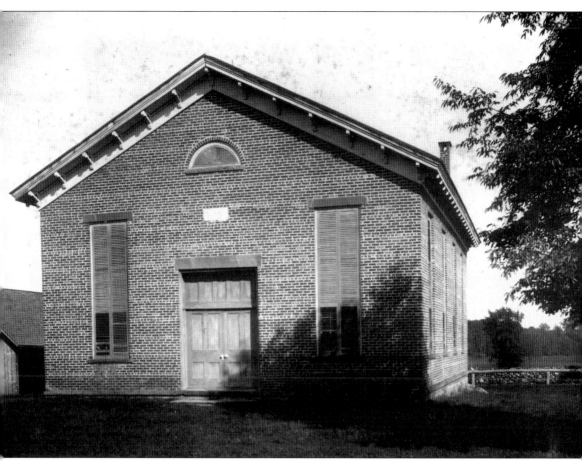

THE NORTH VERNON METHODIST CHURCH. Glenwood was called North Vernon prior to 1868. The North Vernon Methodist Church, shown here in a *c.* 1905 postcard view, was constructed in 1863 on land donated by neighboring farmer Gabriel Houston (who lived in what is now the Apple Valley Inn). By the 1930s, the building was badly in need of repair, and the congregation opted to merge with the Vernon church. The old church was sold to Glenwood farmer Lewis R. Martin in 1933. It was later enlarged with an addition matching the size and shape of the original church, and it was converted to a farm market. For decades now it has been Pochuck Valley Farms, owned and operated by the Vance family, and famous throughout Vernon for its cider, doughnuts, produce, and other wares. (Courtesy Vernon Township Historical Society.)

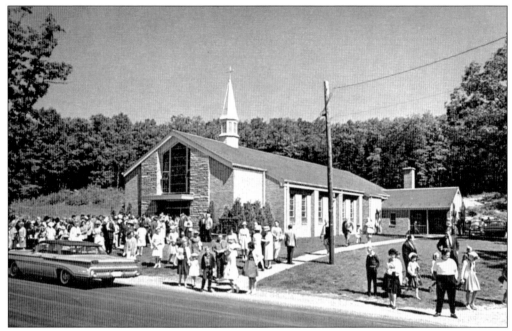

THE MISSION CHAPEL AT HIGHLAND LAKES. Our Lady of Fatima Roman Catholic Church was still a mission when this postcard was published *c*. 1960. Dedicated in 1955, it became its own parish in 1965 under Rev. Aloysius J. Busch, who held the position for more than three decades. (Courtesy Marcela T. Gross.)

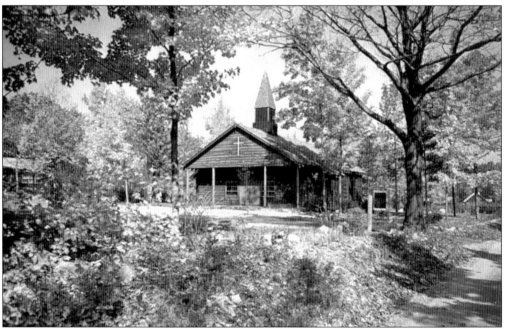

A RUSTIC CHURCH. Emulating the architecture of the community it served, the Highland Lakes Protestant Church on Breakneck Road was built in a rustic style in 1956. It offered only summer services until 1976, when it began year-round operations. It is now Christ Community Church. (Courtesy Harvey Barlow.)

Five

RURAL INDUSTRY

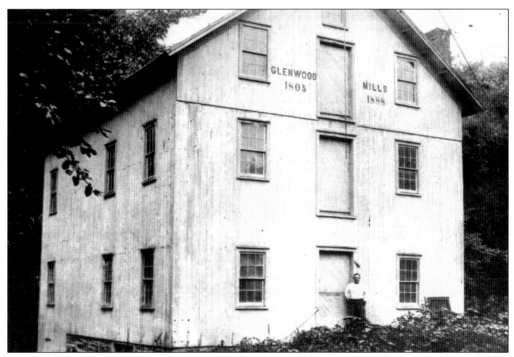

KEEPING HIS NOSE TO THE GRINDSTONE? The miller of Glenwood Mills, shown here *c.* 1900, took a break from his duties to be in the photograph. A hardworking, dutiful miller constantly sniffed the flour where it fed out from between the grinding stones, to be sure it was not being scorched by over-grinding, hence the saying "keep your nose to the grindstone." (Courtesy Vernon Township Historical Society.)

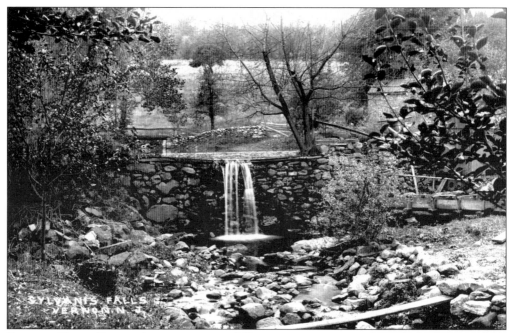

SYLVANIS FALLS. For nearly two centuries, falling water meant one thing in rural New Jersey: industry. Sylvanis E. Wood operated a feed mill on Town Brook south of Vernon, the spillway of which is shown here. Later, a cider mill was built on the site. The millpond is gone, but the Cider Mill House, now Fledglings Montessori School, is still with us. (Courtesy the Antique Photo Store.)

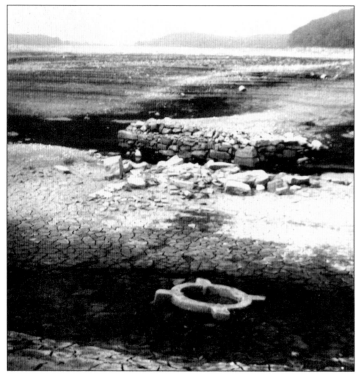

TRACES OF VANISHED INDUSTRY. The Canistear Bloomery forge was built on Pacack Creek in 1796. A little over a century later, the forge and the rest of Canistear village disappeared under the waters of Canistear Reservoir. During the drought of the mid-1960s, traces of it reappeared, as seen here in 1965. Shown is the huge iron cam ring, which was fitted to a water-driven shaft and lifted the massive trip hammer. Beyond it is an old bridge abutment. (Photograph by Edward J. Lenik.)

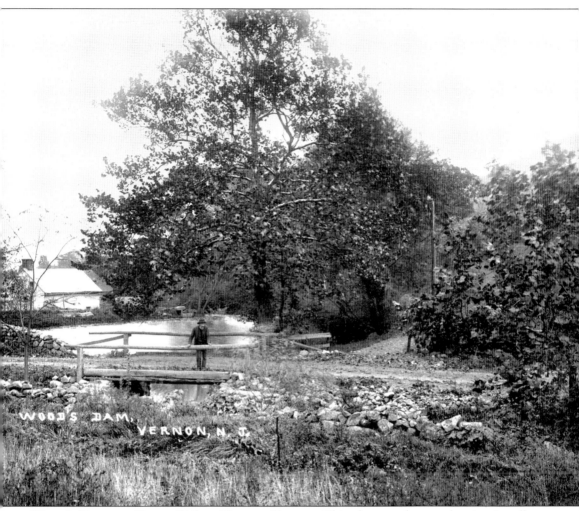

WOOD'S DAM AND ROUTE 515 AT VERNON VILLAGE. This photograph was taken in virtually the opposite direction of the one on the previous page and shows some of the same features. Shown here is present-day Route 515 where it crosses over Town Brook near the Cider Mill House (left background) just south of the A & P shopping center. The millpond beyond the road is the one whose dam is identified as Sylvanis Falls. The man on the bridge may well be Sylvanis E. Wood, who owned the feed mill nearby. This *c.* 1906 A.J. Bloom photograph, printed from the original glass-plate negative, was published as a postcard at the time. (Courtesy the Antique Photo Store.)

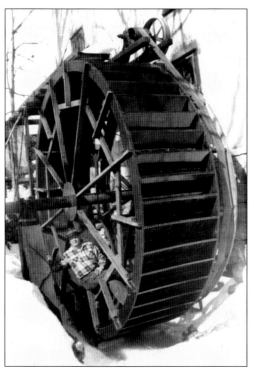

FUN WITH AN OVERSHOT WATERWHEEL. In this 1942 photograph, Dan Van Duzer sits in the waterwheel he built at the Glenwood Grist Mill, which he and his wife Ethel bought in 1939 and converted to a home. Van Duzer was an inveterate tinkerer and hobbyist. His grandfather was Capt. Daniel Bailey, who rebuilt the mill in 1888. The present mill never actually had such a wheel but was powered by turbines. (Courtesy Ethel Van Duzer.)

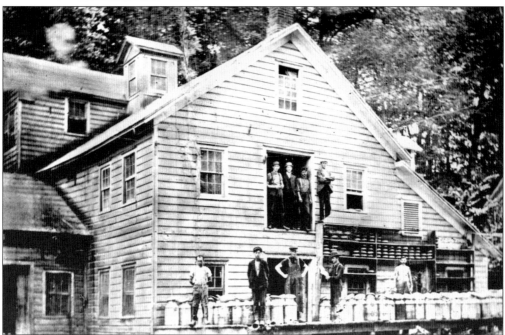

GLENWOOD CREAMERY. The first major dairy processing facility in Vernon Township was the Glenwood Creamery, built in 1865 and shown here c. 1900. It was established by the partnership of Capt. Daniel Bailey and his father-in-law Peter J. Brown, Brown & Bailey. The creamery operated until 1934 and was later torn down. Brown & Bailey operated a number of creameries and were later bought out by Borden's. (Author's collection.)

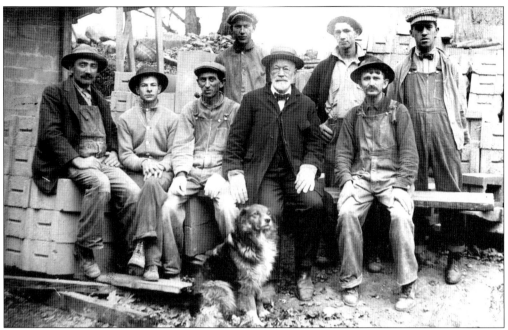

THE CAPTAIN AND HIS WORKMEN. Capt. Daniel Bailey (with the white beard) poses with workmen building a new icehouse for the Glenwood Creamery in this *c.* 1915 photograph. Seen with him, from left to right, are John Van Duzer (Bailey's son-in-law), Charles Fraser, Duke Wellington Park, Joe Lavender, Jack Riesiner, George "Ginger" Park, and ? Roy. Rover, Park's dog, sits in the foreground. (Courtesy Marcela T. Gross.)

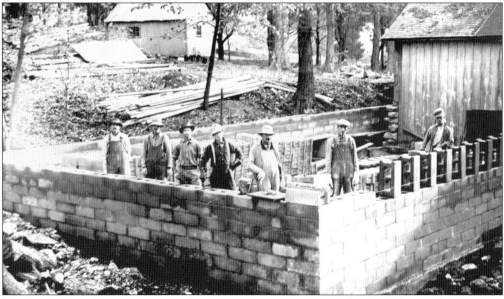

MEN AT WORK. Construction workers build the new icehouse for the Glenwood Creamery. Although the old creamery was modernized to keep up with the times, it was finally condemned and closed in 1934. In 1936, volunteers from the Vernon Township Fire Department salvaged its concrete blocks and used them in construction of the original firehouse on Route 94 in Vernon. (Courtesy Marcela T. Gross.)

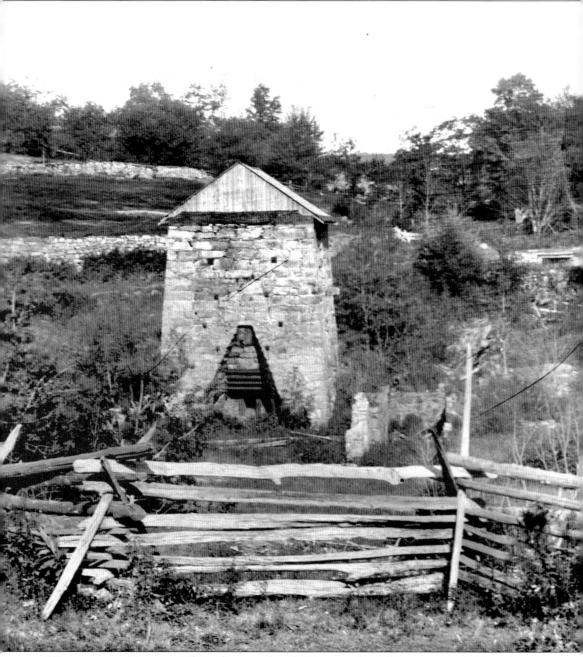

WAWAYANDA VILLAGE. This photograph of Wawayanda village was probably taken in 1889 by J. Percy Crayon, who published a short newspaper history of the furnace that same year. It is one of the few surviving images of the industrial village of Wawayanda. The iron furnace, at the left, was built in 1846 by William L. Ames, whose initials appear on its main lintel. The Ames family was prominent in shovel manufacturing in North Easton,

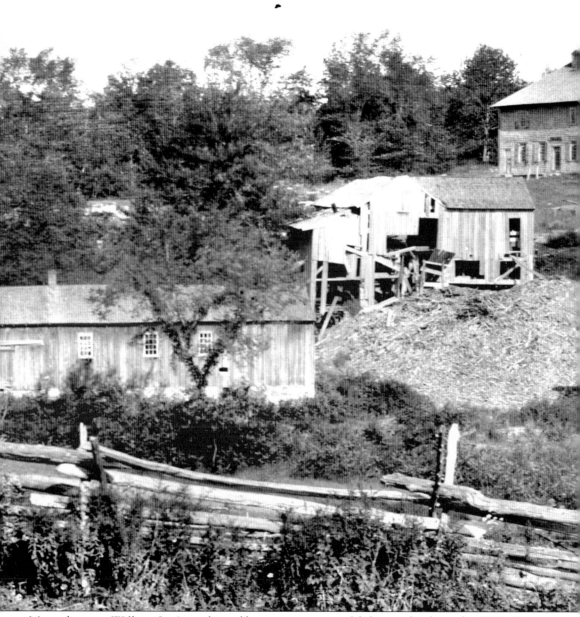

Massachusetts. William L. Ames himself was not as successful: he was bankrupt by 1847. His family retained ownership of the furnace, which ceased operation in 1867. All but the stack itself is gone in this photograph. To the right are the cheese box mill, sawmill, and general store. The mills were gone by c. 1900, and the general store was gone by c. 1920. (Courtesy the Antique Photo Store.)

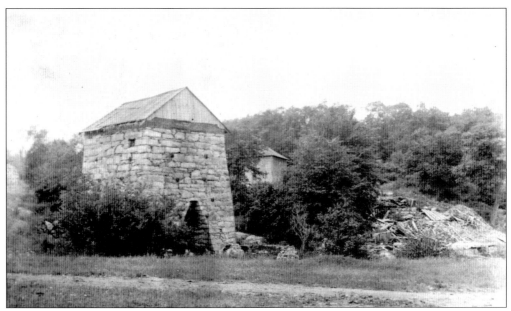

ALL BUT GONE. By the time of this *c.* 1900 photograph, the sawmill and cheesebox factory at Wawayanda had tumbled down, the furnace was in ruins, and the old company store was decrepit. Wawayanda's grimy industrial past was already being replaced with a new role as a place for fishing, camping, boating, and sojourning with nature. (Courtesy North Jersey Highlands Historical Society.)

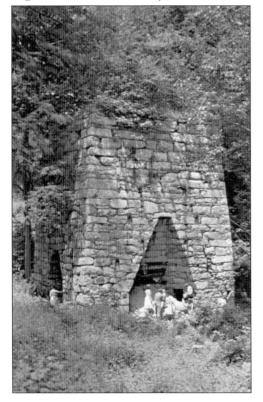

THE WAWAYANDA FURNACE. Seen here is the Wawayanda Iron Furnace, below the main dam at Wawayanda State Park. By the mid-1950s, when this postcard view was taken, the old furnace was an overgrown, Mayan-like ruin in the forest. In the 1980s, the state park preserved the historic furnace with a roof and an external iron-support frame, also removing the vegetation on and around it. Photograph by Bucky McDonnell. (Author's collection.)

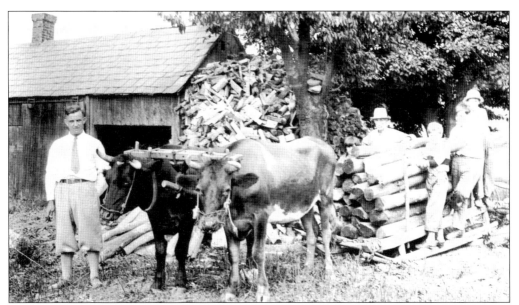

LAYING IN FIREWOOD. Wood was always an important product of our hills, both for fuel and for construction. Here, logs are hauled by a team of oxen at High Breeze Farm on Barrett Road in August 1930. From left to right are Fred Snider, Ferris Barrett, Cliff Blakely, Warren Dehls, and Howie Dehls. Note the huge pile of firewood in the rear. (Courtesy Carolyn Bove.)

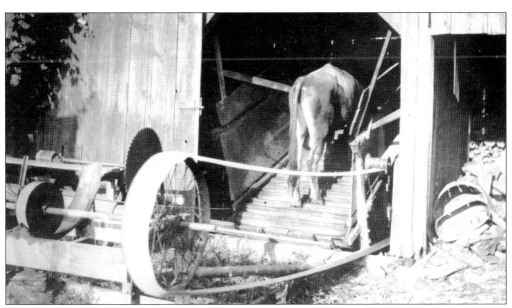

ONE HORSEPOWER, OR IS THAT "COWPOWER"? Before electricity and gasoline engines, local farmers relied on a more basic energy source to power saws and other equipment: animals. Treadmills like this one at High Breeze Farm c. 1925 ranged from dog-and-goat size to ox-and-mule size, and powered everything from butter churns to sawmills. (Courtesy Carolyn Bove.)

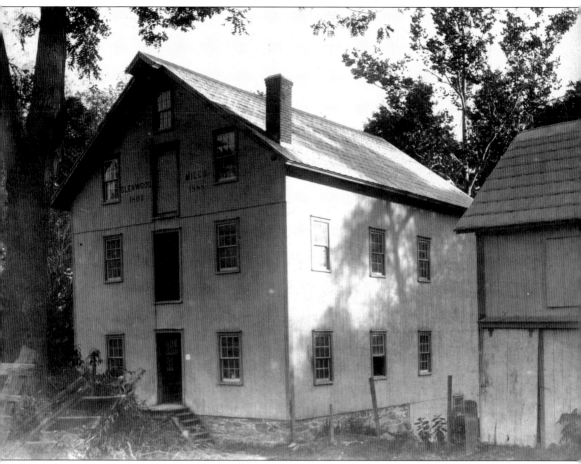

GLENWOOD MILLS. A gristmill was located in Glenwood as early as *c.* 1774. The present mill, shown here *c.* 1900, was built on the site of the original in 1810. In 1888, Capt. Daniel Bailey of Glenwood purchased and enlarged the mill, modernizing it with new equipment and turbines. It operated through World War I but was unable to compete with huge industrial flouring mills and closed in 1919. In 1939, it was purchased by Dan and Ethel Van Duzer, who turned it into a summer home in 1941. Dan Van Duzer (1905–1979) was an ITT Industries engineer and enjoyed restoring and showing off the mill with his wife, Ethel. Today, it is Glenwood Mills Bed and Breakfast Inn, owned by Henry and Susan Capro, and still contains some of its original milling equipment. (Courtesy Vernon Township Historical Society.)

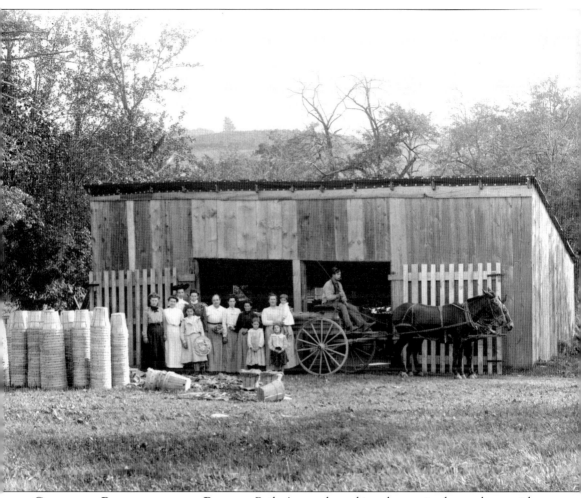

GLENWOOD PEACHES BY THE BUSHEL. Bailey's peach-packing house is shown here with employees *c.* 1905. The peach harvest came on heavy in September, providing a few frantic weeks of work. It was the job of these women to sort and pack the fruit into bushel baskets. The baskets were then loaded on wagons and transported to the nearby railroad freight house, where they were shipped out on the Lehigh & New England Railroad via the Pochuck Railroad. On the wagon is Frank Monks, one of Capt. Daniel Bailey's right-hand men. Among the women pictured are Minnie Drake, Alida Monks Williams, Delia Bailey Reed (the captain's daughter), and Lizzie Bailey (the captain's wife). The peach-packing house is long gone now. (Courtesy Ethel Monks Van Duzer and Dorothy Ji.)

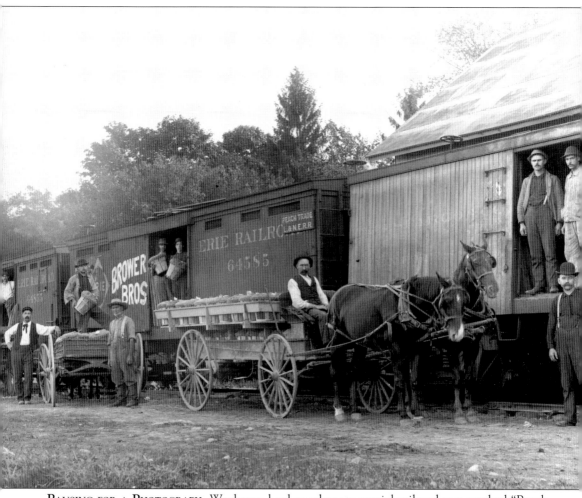

Pausing for a Photograph. Workmen load peaches on special railroad cars marked "Peach Trade, L. & N.E.R.R.," at the Glenwood freight house *c.* 1905. The peaches were shipped out on the Lehigh & New England Railroad via the Pochuck Railroad. Thousands of peach trees grew in orchards where Glenwood Estates is now located, and the fruit was a major source of income for Glenwood. This photograph by A.J. Bloom, printed from the original glass-plate negative, and the one on the cover of this book were taken at the same time. (Courtesy the Antique Photo Store.)

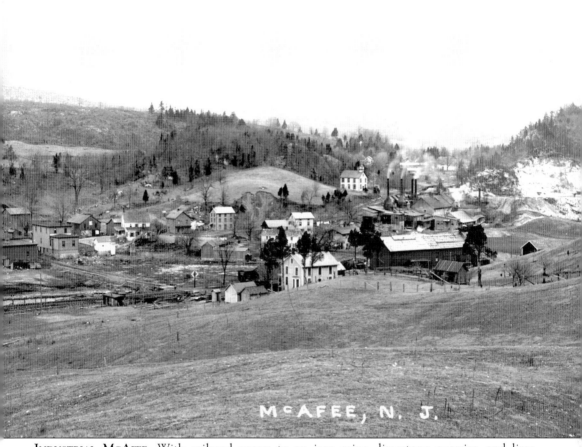

MCAFEE, N. J.

INDUSTRIAL MCAFEE. With railroad access to an iron mine, limestone quarries, and lime kilns, McAfee was a substantial industrial village from the 1870s through the 1920s. The railroad first came to Vernon at McAfee in 1871, and it also led to the construction of stores and taverns. This *c.* 1906 A.J. Bloom photograph of the village, taken from Rudetown Road, shows the area roughly around the intersection of Routes 94 and 517 at the traffic light. It also shows Pochuck Mountain cleared of trees to its summit. The trees were probably cut down as fuel for the lime kilns. First built in 1872 by the White Rock Lime & Cement Company, the kilns were rebuilt and expanded from the 1880s until the second decade of the 20th century. They produced lime for both agriculture and masonry. In this view, the limestone quarry and kilns are running full blast (note the smoke coming from the smokestacks), but by *c.* 1914, they had closed permanently. Also shown is the old McAfee schoolhouse up on the hill opposite the quarry. This print was made from the original glass-plate negative. (Courtesy the Antique Photo Store.)

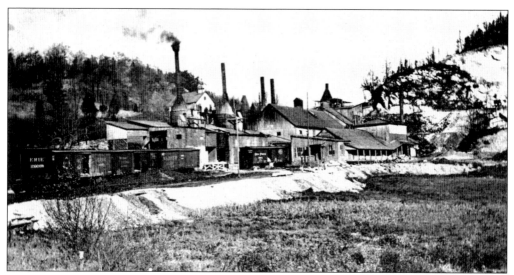

Burning the White Rock. The New Jersey Lime Works, located north of the intersection of Routes 94 and 517 in McAfee, were an important part of Vernon's economy for over 50 years. Nothing now remains of the large complex, shown in this postcard view *c.* 1907, except the masonry kilns (hidden under smokestacks and roofs), the ruins of which are now visible behind the parking lot of the McAfee Union Bible Church. (Courtesy Marcela T. Gross.)

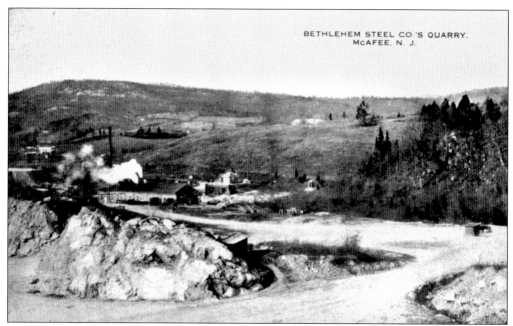

Shipping to Pennsylvania. The Bethlehem Steel Company bought a limestone quarry in McAfee in 1903. Today, this view is looking west from Route 94 north of Legends Stables across the golf course, with Pochuck Mountain in the distance. Bethlehem Steel needed crushed limestone for its iron-smelting furnaces in Pennsylvania. McAfee's quarries, with vast open spaces and sheer cliffs, were the result of Bethlehem Steel's new blasting and quarrying techniques employed after *c.* 1910. (Author's collection.)

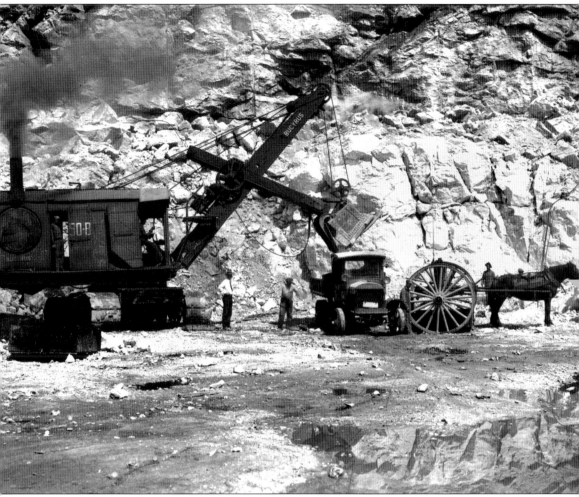

LIMESTONE BY THE HORSE LOAD OR TRUCKLOAD. This A.J. Bloom photograph shows typical limestone quarrying techniques of the 1920s. A steam shovel is used to deposit loose limestone in a pickup truck, while a nearby team of men appear to be rigging explosives for the next blast. Although both this and the bottom photograph on page 78 represent the kind of quarrying techniques used at McAfee, they were actually taken just over the border at a quarry near Hamburg (probably the one at Rudetown, now Crystal Springs) on December 6, 1927. The McAfee quarry had closed the year prior. This print was made from the original glass-plate negative. (Courtesy the Antique Photo Store.)

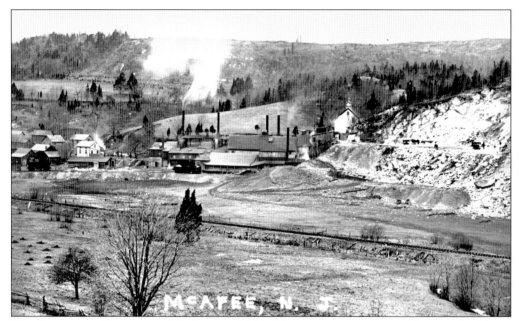

THE LIMESTONE QUARRY AT MCAFEE C. 1906. Limestone quarrying and burning had been occurring on a small scale in Vernon Township since *c.* 1815, but when the railroad came to McAfee in 1871, it became big business. The quarry and kilns are seen here in their prime, photographed by A.J. Bloom. A rail spur runs to the kilns, but the quarries are still using mules and wagons. By World War I, the kilns had become history. (Courtesy the Antique Photo Store.)

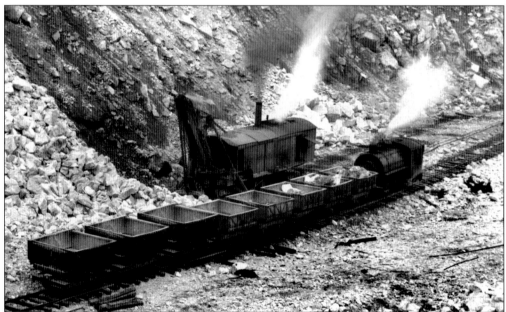

LIMESTONE BY THE CARLOAD. In order to increase efficiency, a railroad spur would be run directly into the limestone quarry, as shown in this 1927 photograph. Here, a track has been laid adjacent to the freshly dislodged limestone, and a steam shovel is loading the gondola cars with stone. (Courtesy the Antique Photo Store.)

Six

TRANSPORTATION

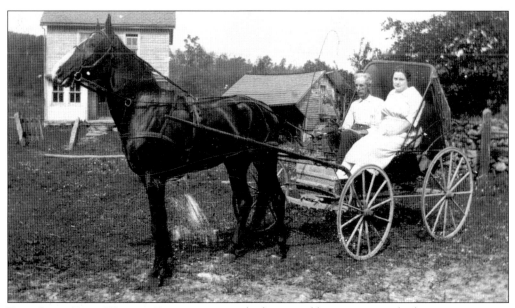

FOUR LEGS, FOUR WHEELS. For generations, the horse and buggy was standard transportation in Vernon. In winter, the buggy was put in storage and out came the sleigh. Shown here *c.* 1915 are Ferris Barrett and his young wife, Blanche, in front of their house at High Breeze Farm on Barrett Road. (Courtesy Carolyn Bove.)

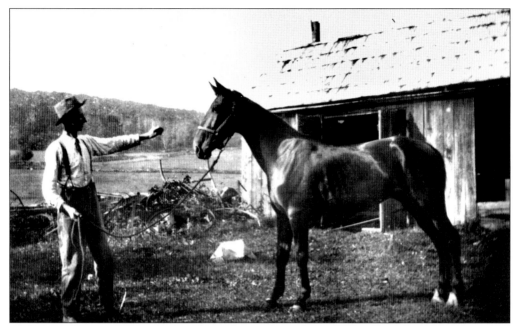

A YOUNG PROSPECT. Breeding and training carriage horses was an important trade in the days before automobiles. Ferris Barrett, shown here with a young horse *c.* 1910 in front of his blacksmith shop at High Breeze Farm, was one of the best horse trainers in Vernon. A promising colt bought for $50 might be raised up and trained into a first-rate carriage horse fetching up to $1,000. (Courtesy Carolyn Bove.)

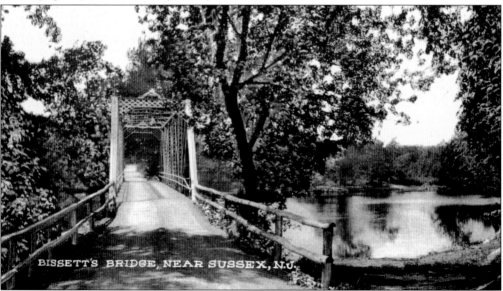

BISSETT'S BRIDGE, NEAR SUSSEX, N.J.

ACROSS THE WALLKILL. Bassett's, or Bissett's, Bridge, as it is spelled here, is shown *c.* 1910, when an iron truss bridge carried travelers across the Wallkill River between Vernon and Wantage, now Bassett's Bridge Road. The spelling is not an error; the name is authentically pronounced *Bazzatt* or *Bissette* (with emphasis on the second syllable), and spellings varied widely. It received its name from the original bridge tender and toll collector in Civil War times. (Courtesy Marcela T. Gross.)

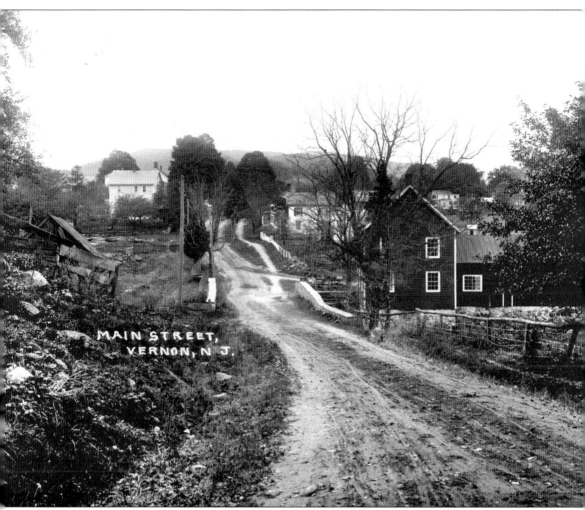

VERNON VILLAGE'S "MAIN STREET." This *c.* 1906 A.J. Bloom photograph shows Route 94 as it heads south towards its intersection with Vernon Crossing Road, just beyond the Vernon Grange Store (today's Cardinal Art Gallery) on the right. Route 94 is an ancient highway, likely following a Native American footpath, and was first laid out as the King's Highway in 1735. The road looks good enough in this photograph, but one can appreciate how in late winter and early spring, it, along with all unpaved roads, became little more than a linear quagmire. Vernon would not have electricity for another 30 years, but telephone poles were already present on this humble main street, which looks like a dog could safely nap in the middle of it. (Courtesy the Antique Photo Store.)

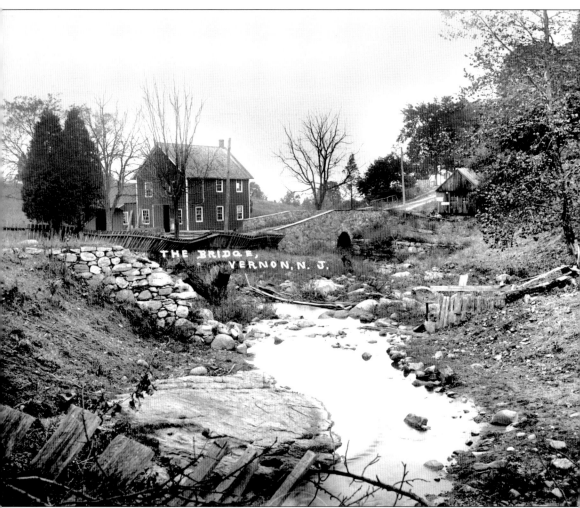

"THE BRIDGE," VERNON VILLAGE. The old stone bridge featured in this c. 1906 postcard is where Town Brook flows under modern Route 94. At the left center is the Vernon Grange Store. Although the handsome single-arch stone bridge was long ago replaced with a modern highway culvert, the store building survives and is the present-day Cardinal Art Gallery, at the intersection of Route 94 and Vernon Crossing Road. This A.J. Bloom photograph was printed from the original glass-plate negative. (Courtesy the Antique Photo Store.)

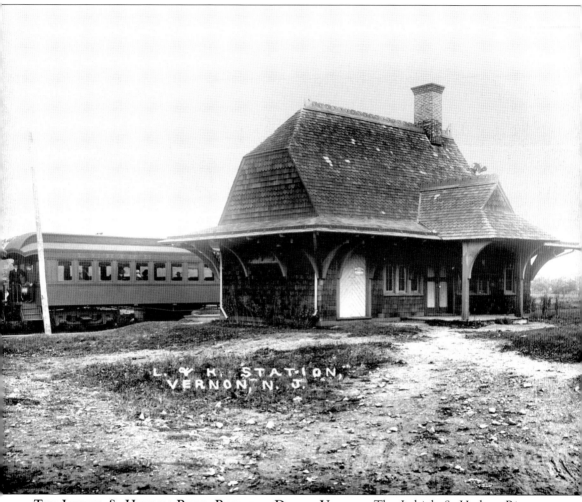

THE LEHIGH & HUDSON RIVER RAILROAD DEPOT, VERNON. The Lehigh & Hudson River Railroad broke ground in 1879, and it was completed through Vernon Township in 1880. Two of its distinctive depots were built in 1881, one at McAfee and one at Vernon. As seen here, the Vernon depot was a passenger station (note the handsome old passenger cars); freight and dairy were loaded nearby. It ceased to serve as a railroad station in the early 1950s and was closed by the railroad in 1957. Since then it has housed several businesses, most notably Place By The Tracks delicatessen. This *c.* 1906 A.J. Bloom photograph was printed from the original glass-plate negative. (Courtesy the Antique Photo Store.)

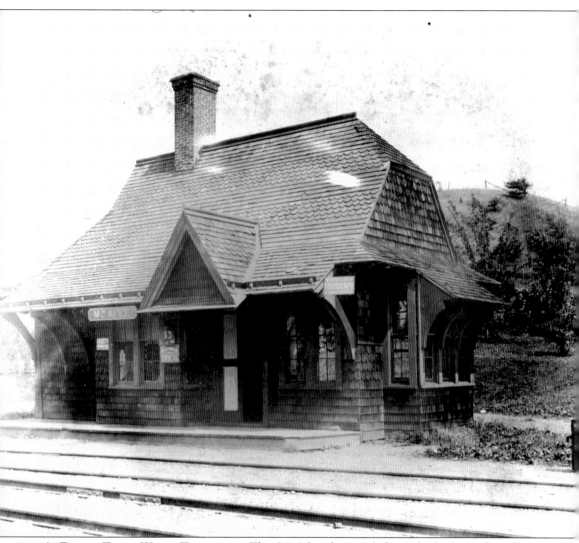

A Depot That Went Traveling. The McAfee depot of the Lehigh & Hudson River Railroad, built in 1881, stood on the southeast side of the tracks at the end of a short road that led to present-day Route 94 between the firehouse and the George Inn. Essentially a twin of the Vernon depot, it included a Western Union telegraph and cable office and a Wells Fargo agency. This depot was closed and sold off by the railroad in the late 1950s. Its new owner jacked it up and hauled it north up Route 94 just across the border to New Milford, New York, where it still stands, in use as a residence. The large hill seen behind it here was later cut away by soil quarrying. This view, which was probably taken by A.J. Bloom c. 1906, was published as a postcard at the time. The print order on the back of the original notes that only 27 of the postcards were printed, hence they are rare indeed. (Courtesy Vernon Township Historical Society.)

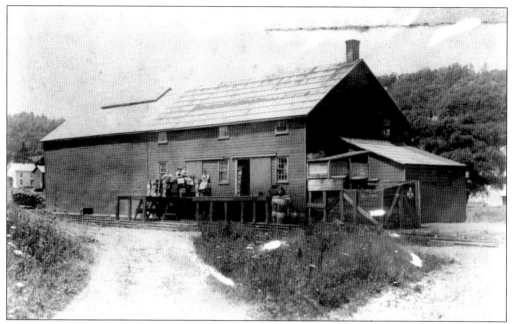

A NEW CONVENIENCE. When the McAfee Creamery was built in 1902, it saved farmers the trouble of taking their milk to Hamburg or Vernon. Sparks from a passing train set it afire and destroyed it in 1918; it was never rebuilt. It stood alongside the railroad tracks on the south side of present-day Route 94, a site now overgrown with trees. (Courtesy Vernon Township Historical Society.)

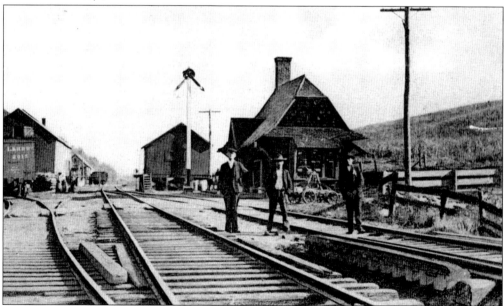

McAFEE, A RAILROAD HAMLET. When the Sussex Railroad came to the sleepy village of McAfee Valley (later shortened to McAfee) in 1871, the village literally exploded with growth. Within a few years, new stores, taverns, houses, a quarry, a mine, and a lime works were built. The village would not experience such growth again for another century, when it was brought on not by the iron horse, but by the Playboy bunny. (Courtesy Wayne T. McCabe.)

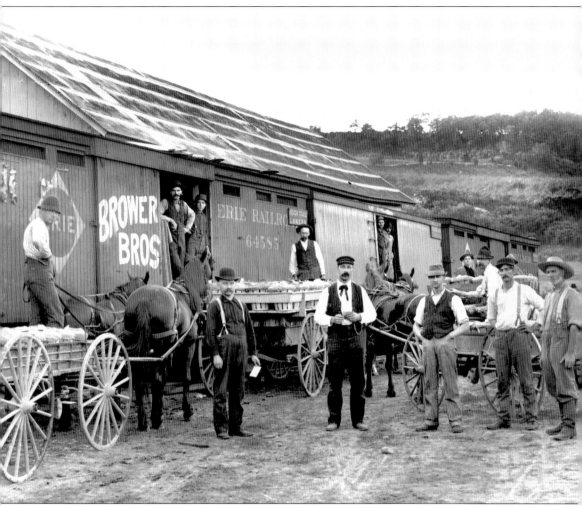

TRAINLOADS OF PEACHES AT GLENWOOD. This promotional photograph, which also appears on the cover of this volume, shows peaches being loaded at the freight house near the Glenwood depot *c.* 1905. In the center, wearing a tie and cap, is Matt Bailey (1864–1927), son of Capt. Daniel Bailey. Bailey's peach orchards produced tens of thousands of bushels of peaches annually. The nearby creamery shipped out up to 125 pails of milk per day. Both were shipped out via the Pochuck Railroad. This A.J. Bloom photograph was printed from the original glass-plate negative. (Courtesy the Antique Photo Store.)

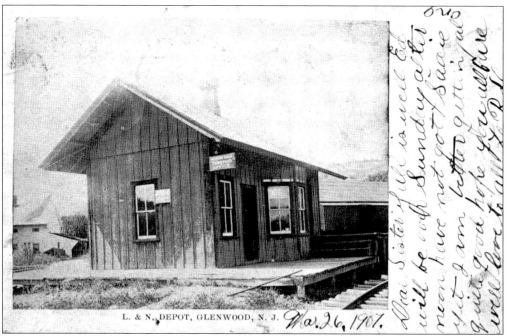

L. & N. DEPOT, GLENWOOD, N. J. *Mar. 26, 1907.*

THE END OF THE POCHUCK LINE. The Glenwood depot of the Lehigh & New England Railroad was the last—and only—depot on the Pochuck Railroad, a branch of the Lehigh & New England that ended at Glenwood. The railroad had a short life, lasting only from 1898 to 1926. The depot, shown here *c.* 1907, survives today as a dwelling just off of Route 565. (Courtesy Marcela T. Gross.)

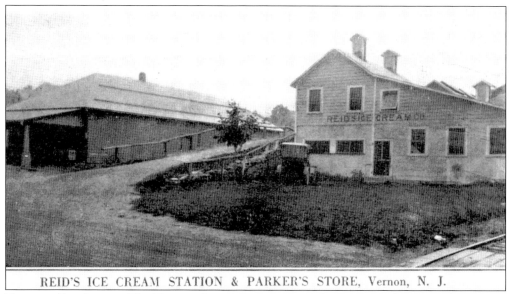

REID'S ICE CREAM STATION & PARKER'S STORE, Vernon, N. J.

FIRE AND ICE CREAM. The Vernon Creamery on Vernon Crossing Road next to the railroad tracks had a history of fires, suffering three. They occurred in 1907, 1916, and 1942. The last fire ended the creamery's existence, and today only the lower concrete portion of the building survives, overgrown and in ruins. The creamery is shown here *c.* 1916 when it was a milk-collecting station for Reid's Ice Cream Company. (Courtesy Marcela T. Gross.)

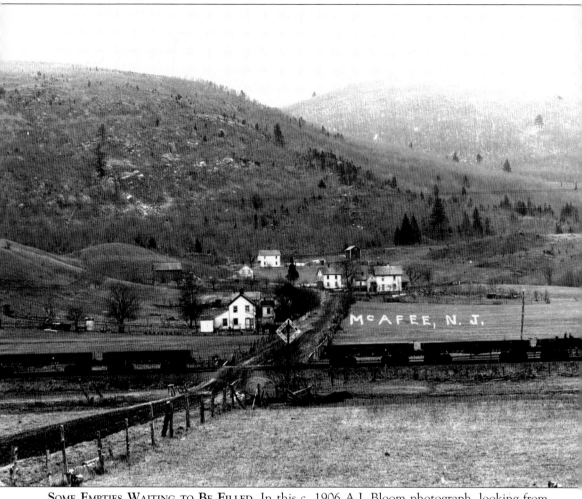

Some Empties Waiting to Be Filled. In this *c.* 1906 A.J. Bloom photograph, looking from Route 94 near the McAfee Library along Old Rudetown Road, railroad gondola cars sit empty where Old Rudetown Road crosses the Lehigh & Hudson River Railroad tracks. In short order, they would be filled with limestone from the nearby quarry and shipped to Bethlehem, Pennsylvania, where the limestone was used in iron making. This was a common sight from 1901 to 1926. Note that the railroad left a gap in the rail cars so that traffic could pass through. Note also that Hamburg Mountain is nearly denuded of timber in areas, a testimony to the value of the forest as fuel, railroad ties, and mine props. (Courtesy the Antique Photo Store.)

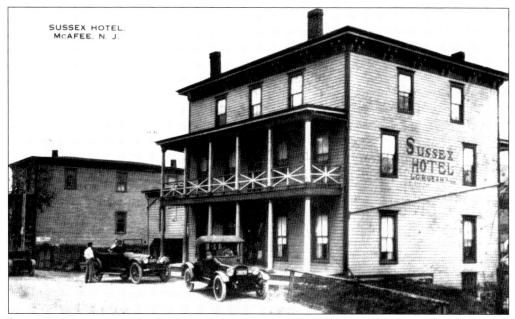

FROM RAILROADS TO TIN LIZZIES. Simpson's Hotel was built when the railroad came to McAfee, but it prospered nicely into the age of the automobile, as seen in this *c.* 1916 view, which shows several jalopies out front. Under the ownership of Leon C. Ruban, it became the Sussex Hotel. Alas, prohibition arrived in 1920 and put a damper on this popular foam-dispensing emporium. Ruban sold the hotel in 1925, and it eventually became the George Inn. (Author's collection.)

PRIDE OF OWNERSHIP. They chose to have their extended family portrait taken around the family touring car. That says something about the Houghtaling (also spelled Hotaling) family, shown here in 1914. At a time when many still relied on horsepower to get around, an automobile was a definite prestige item. The location of the photograph is not noted on the original. (Courtesy Vernon Township Historical Society.)

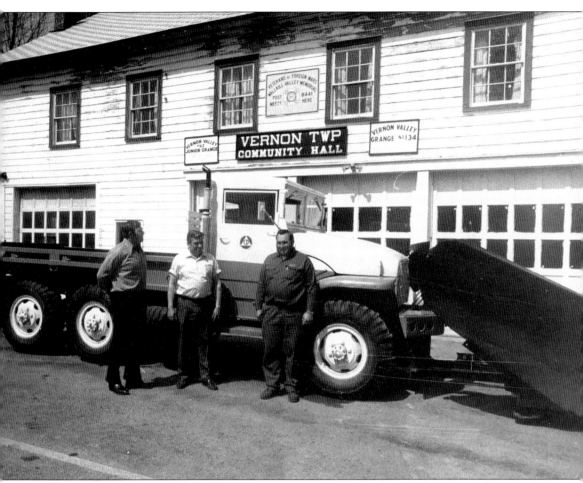

MODERN EQUIPMENT FOR MODERN HIGHWAYS. Though the sign reads "Vernon Twp. Community Hall," this building on Vernon Crossing Road near Route 94 was universally called the Grange Hall. The Grange met there, as did many other civic and social groups, including the town council. Built *c.* 1920 with a hall upstairs and municipal garages downstairs, it served a multitude of purposes, notably as the headquarters of the road department, as seen here. As well-remembered as it was, the Grange Hall did not survive the age of modern building and fire codes. It was torn down *c.* 1980, after the present municipal center was built in 1978. Shown here *c.* 1972 are, from left to right, Warren Baldwin, Kip Riggs, and Bob Baldwin. The Baldwin family has long been prominent in Vernon's business, civic, and political life, and Riggs was for many decades supervisor of the public works department. (Courtesy Vernon Township Historical Society.)

Seven

SOME NOTABLE RESIDENTS

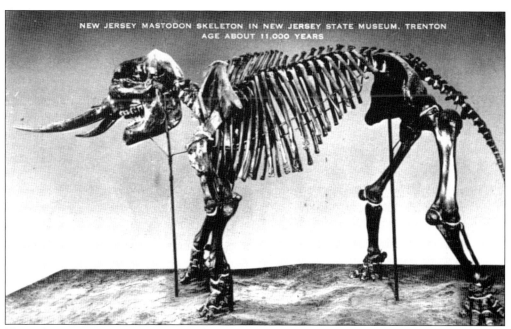

THEY ONCE ROAMED OUR HILLS. This skeleton of a young female mastodon was recovered during the dredging of Ohberg's Pond on Highland Lakes Road in 1954. Looking in life much like a hairy elephant, Matilda, as she was called, was part of a herd of mastodons that foraged here in roughly 9000 B.C. She is on display in the state museum in Trenton. (Courtesy Marcela T. Gross.)

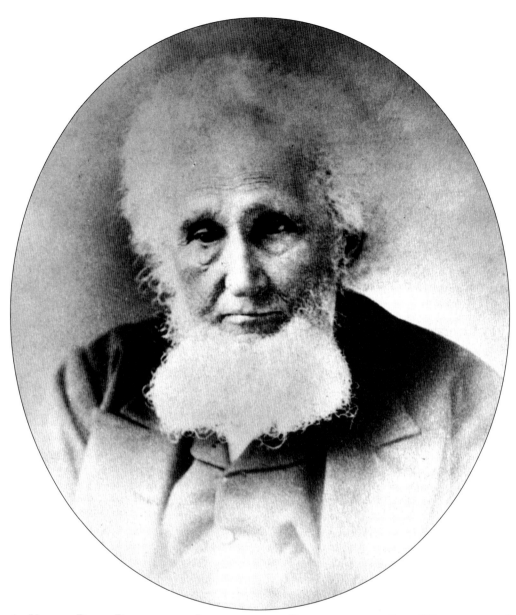

A Vernon-Born Railroading Inventor and Philanthropist. Ross Winans, son of Vernon tavern keeper William Winans, was born in Vernon in 1796. By the 1820s, he was tinkering with ideas for the new technology of railroads. Moving to Baltimore, Maryland, he put his talents to work for the Baltimore & Ohio Railroad and went on to become one of the notable inventive figures of American railroading. Among his developments were the original camelback locomotive and the four-wheeled rotating undercarriage that became universal on American railroad cars. He grew rich from his inventions and business enterprises, and he turned his voracious intellect to other enterprises, including developing new types of steamships, a pneumatic cannon, and experimental agriculture. He spent his old age interested in philanthropy and religion and wrote several books on theology. Meanwhile, his sons were hired by the czar of Russia to oversee construction of the country's first railroad, which ran from Moscow to St. Petersburg. (Courtesy the Maryland Historical Society, Baltimore.)

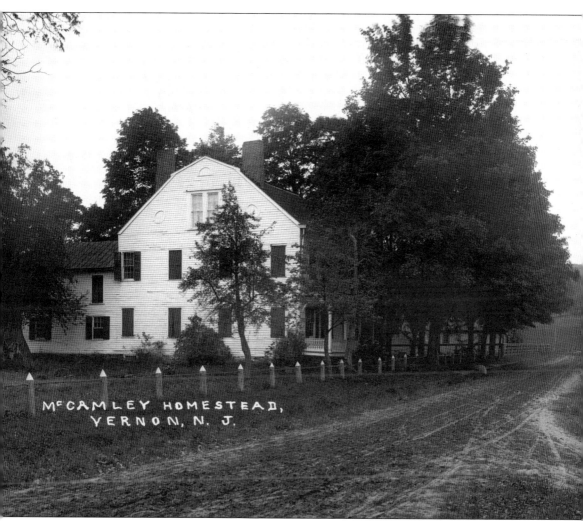

McCAMLEY HOMESTEAD,
VERNON, N. J.

VERNON'S MOST-FAMOUS ATTIC. This home was built by Capt. William Vibbert, a sea captain who intended to retire to Vernon but did not live to do so, as he drowned at sea. Ross Winans's father, William Winans, purchased the home in 1827, and Ross soon used its large attic to construct an experimental scale railroad, demonstrating the wheel bearing on which he would obtain a U.S. patent in 1828. The *New Jersey Herald* of July 25, 1888, published a lengthy article on Ross Winans and said of the McCamley homestead, "The house is a large old-fashioned mansion, with hip roof, beneath which is a very spacious garret . . . here some of the most useful inventions connected with railways were developed." The house was owned by the McCamleys through the late 1800s. Theodore Frelinguysen Wood, a circus showman and entrepreneur, married into the family and lived here in the 1870s and 1880s. It was later owned by Dr. Edward M. Livingston, coauthor of one of the first standard reference works on cancer. It is now Coldwell Banker Realtors, on Route 515. (Courtesy the Antique Photo Store.)

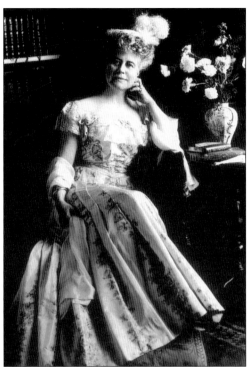

A Woman and Her Garden. Helena Rutherfurd Ely (1858–1920) had a large summer home, Meadowburn Farm, near the state line in Vernon. Improving its ancient gardens, she became a de facto regional expert on perennial gardening and finally put her expertise into a book, *A Woman's Hardy Garden*, published in 1903. An immediate hit, it sold 40,000 copies and is still in print a century later. (Courtesy Deborah and B. Danforth Ely.)

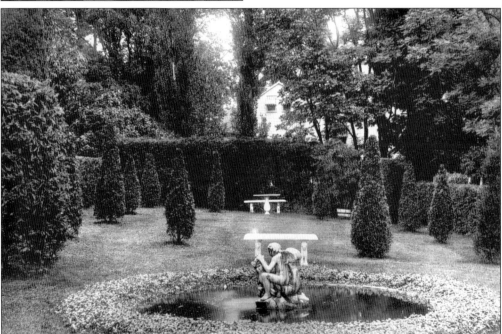

The Fountain Garden. The house and gardens at Meadowburn Farm were listed on the New Jersey and National Registers of Historic Places in 1993 in honor of Helena Rutherfurd Ely's unique contributions to the history of gardening in America. As with most of the gardens she designed at Meadowburn, the Fountain Garden shown here still exists. (Courtesy Deborah and B. Danforth Ely.)

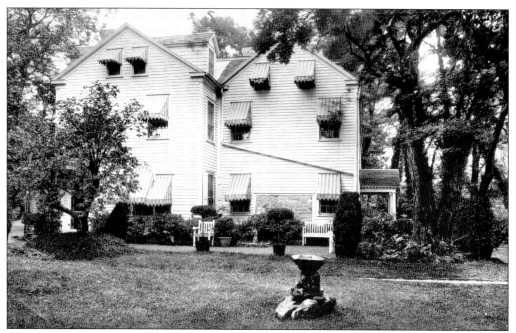

A COLONIAL MANSION. Alfred and Helena Rutherfurd Ely were given Meadowburn Farm as a wedding present in 1881. The property included an ancient house, the oldest portion of which was built by William Willet DeKay in the 1750s. The head gardener in Helena Ely's day was Albert Furman. Meadowburn Farm, shown here *c.* 1910, has been owned by the Coster and Gerard families since 1930, but a Furman, Albert Furman Jr., still oversees the gardens. (Courtesy Deborah and B. Danforth Ely.)

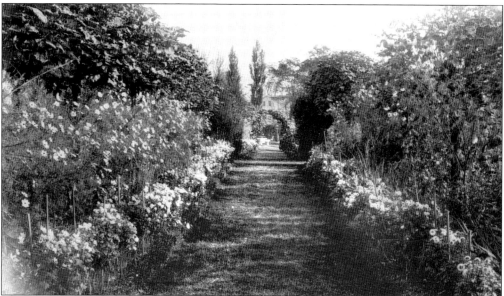

PERENNIAL BORDERS. The gardens at Meadowburn Farm were famous in Helena Ely's day, and look today much as they did in her time, a century ago. Her other gardening books include *Another Hardy Garden Book,* published in 1905, and *The Practical Flower Garden,* published in 1911. Shown here is the garden walk *c.* 1903. (Courtesy Deborah and B. Danforth Ely.)

A MAN OF MANY ROLES. Actor Edgar Stehli (1884–1973) was a star on the Broadway stage for over 60 years. He also played many roles in radio, television, and the movies. During his long career, he starred with the likes of John Barrymore, Boris Karloff, and Jason Robards. Buying a small farm in Vernon in 1928, Stehli spent vacations in our town for the remainder of his long life. (Courtesy Nancy Stehli Knoerzer.)

AN ARISTOCRAT OF FASHION. Nicolas de Gunzburg (1902–1981) came to America in 1936 and established himself as one of the keenest eyes in the fashion industry. An editor at *Town & Country* and *Harpers Bazaar*, he was fashion editor at *Vogue* from 1950 until his death. In 1960, he built a summer house on his own island in Highland Lakes, which reflected his cultivated tastes. His protégés included Oscar de la Renta, Bill Blass, and Calvin Klein. This photograph was taken by Hurrell. (Author's collection.)

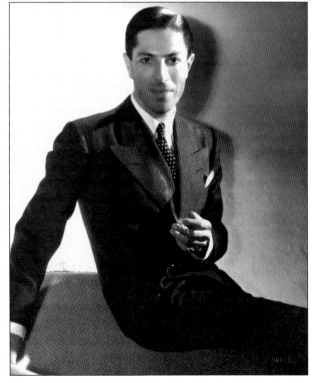

A Vernon Sculptor and Farmer. Reuben Kadish (1913–1992) was part of an artistic circle that included his friends Jackson Pollock, Philip Guston, Willem de Kooning, Mark Rothko, and David Smith. After buying a dairy farm on Price's Switch Road in 1946, Kadish divided his time between New York City, where he taught art at Cooper Union, and farming in Vernon. His work is included in the collections of the Museum of Modern Art. (Photograph by Regina Cherry, courtesy Dan Kadish.)

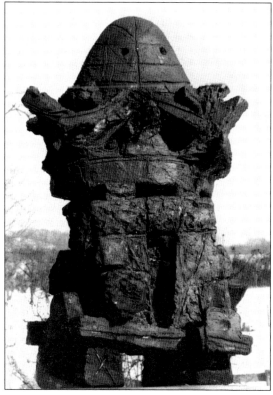

Primitive Modern. Originally working in frescoes, painting, and drawing, Reuben Kadish became a prominent printmaker and a sculptor in bronze and terra cotta from the late 1940s until his death. Though somewhat abstract, his sculpture projected a figurative, primitive earthiness. Shown here is *Double-Jack,* sculpted in 1958. (Courtesy Dan Kadish.)

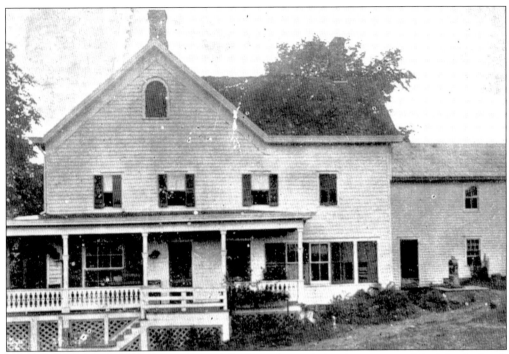

THE BAILEY HOMESTEAD. Young Daniel Bailey inherited this home upon his father's death in 1860, and he lived here until his death 63 years later. The house, shown *c.* 1906, stood on the corner of Route 565 and Armstrong Drive in Glenwood. It was destroyed by fire in 1983. (Courtesy Wayne T. McCabe.)

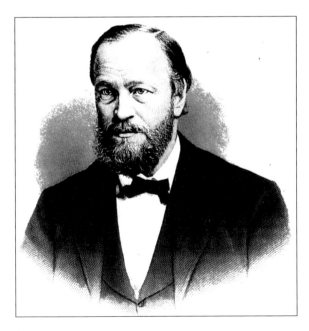

THE GODFATHER OF GLENWOOD. From the 1860s through the 1920s, nobody had a more prominent role in the life of Glenwood than Capt. Daniel Bailey (1841–1923). Born in Glenwood, he served in Virginia and Kentucky during the Civil War and was wounded. Back in Glenwood, he expanded his ancestral family holdings into a small empire, including creameries, peach orchards, a general store, a gristmill, a telegraph line, numerous farms, and a major interest in the Pochuck Railroad. (From James P. Snell's *History of Sussex and Warren Counties.*)

Eight

CAMPS, RESORTS, AND RECREATION

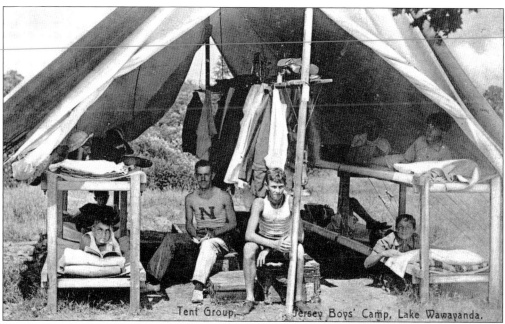

Tent Group, Jersey Boys' Camp, Lake Wawayanda.

A TENT GROUP ON A SAND SHORE. Camp Wawayanda is regarded as the first permanent YMCA summer camp in the United States, and the program carried the name Wawayanda to its later camps (the present one being in the Catskills). The camp was established by Sumner F. Dudley in the 1880s and left Lake Wawayanda after the property was purchased by the New Jersey Zinc Company in 1919. A typical tent group is shown here c. 1909. (Courtesy Marcela T. Gross.)

A POPULAR LAKE FOR OVER 150 YEARS. Hudson River school artist Jasper F. Cropsey painted this oil view of Lake Wawayanda in 1846, by which time the lake was already attracting fishermen. At the time, this was a new view, Lake Wawayanda only having just been created by damming up the outflow of the Double Ponds. It was dammed to provide power for the nearby furnace that was then being built. This is the shore where the beach is now located. (Private collection.)

THE SECOND-HIGHEST NATURAL LAKE. Of natural lakes in New Jersey, only Lake Marcia at High Point is higher than Lake Pochung atop Pochuck Mountain. Originally called Decker Pond, Lake Pochung was renamed by a group of sportsmen who organized the Lake Pochung Club c. 1899. As shown in this c. 1906 postcard view, fishing was a favorite activity. (Courtesy Vernon Township Historical Society.)

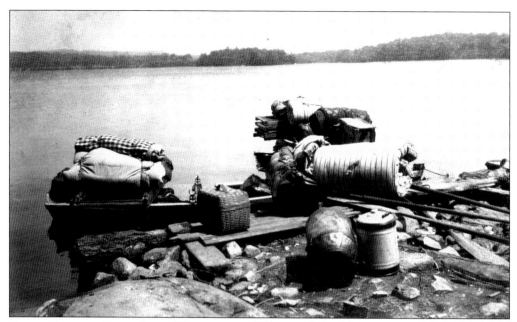

EARLY CAMPING GEAR, LAKE WAWAYANDA. Wawayanda had become a popular fishing and camping spot by the 1870s, and many Sussex, Orange, and Passaic County families and groups visited it. Arriving here via rowboat, early campers' gear included most everything but the kitchen sink (and probably even that, sometimes). (Courtesy Marcela T. Gross.)

OUTDOOR RELAXATION. These campers at Wawayanda seem less interested in admiring nature than in smoking, reading, and cardplaying, for which they brought a table and chairs. The platform in this c. 1900 view was presumably provided for the convenience of tent campers. (Courtesy Marcela T. Gross.)

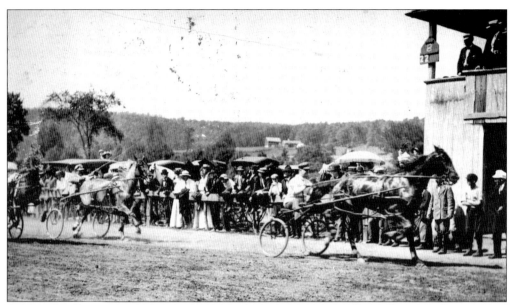

AT THE OLD POCHUCK TRACK. Pochuck Track, a trotting racetrack, was located off Drew Road near Route 517 and operated from at least the 1850s until *c.* 1910. It drew such large crowds that it was often called the "World's Fair track." It was replaced by a new, larger racetrack at McAfee in 1913. Shown here is Dr. E.P. Uptegrove of Vernon turning in a nice finish. (Courtesy Harvey Barlow.)

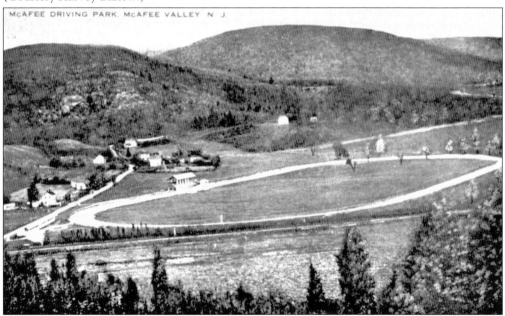

McAFEE DRIVING PARK, McAFEE VALLEY N J.

AND THEY'RE OFF! McAfee once boasted one of the best trotting racetracks in northern New Jersey. Built in 1913 on Old Rudetown Road by an association of McAfee businessmen and trotting enthusiasts, it included a half-mile track and a grandstand with a capacity of 600. It replaced the old Pochuck racetrack near Spraguetown, which had been in use since the 1850s. The new track also had the advantage of being close to the McAfee train station. (Courtesy Wayne T. McCabe.)

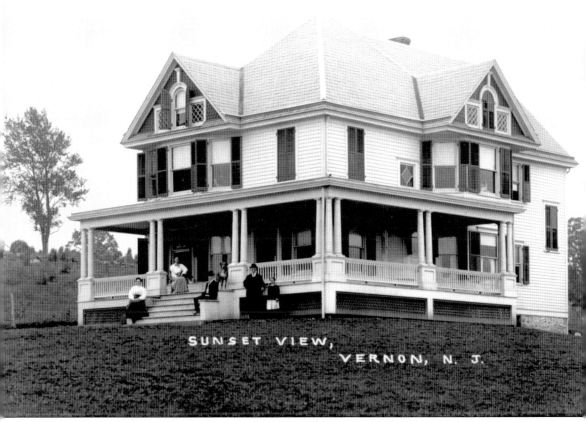

SUNSET VIEW,

VERNON, N. J.

THE SUNSET VIEW HOTEL. When the Lehigh & Hudson River Railroad came through Vernon in 1880, it facilitated a popular trend of establishing and using summer boardinghouses. Many farm families adapted their existing homes to summer boarding trade, but the Mott family built a new house with just this in mind. Sunset View was built c. 1905 by Charles T. Mott on Vernon Crossing Road just below present-day Church Street near the Lehigh & Hudson River Railroad station and Mott's own store. The once elegant inn, later simply a home, stood dilapidated for many years and was badly damaged by a fire in 2001. However, it has been rebuilt with much of its original style in mind. This c. 1906 A.J. Bloom photograph was printed from the original glass-plate negative. (Courtesy the Antique Photo Store.)

HIGH BREEZE HOUSE. Like many area farm families, the Barretts of Barrett Road supplemented their income by leasing rooms to summer boarders from the city. In the early 1890s, Jim Ed Barrett added a wing just for boarders, seen on the left in this view. The wing was not quite as impressive as it looked, as it was only half as wide as the rest of the house and contained only three rooms. When boarders were in residence, the Barretts would move into the small kitchen wing of their house. A room with meals at High Breeze House cost $6 a week. The boardinghouse wing at High Breeze was taken down after about 10 years, but the ever frugal Barretts saved the interior wainscoting and iron beds, which were still neatly stacked in the attic of the main house in the mid-1980s, 80 years later. (Courtesy Carolyn Bove.)

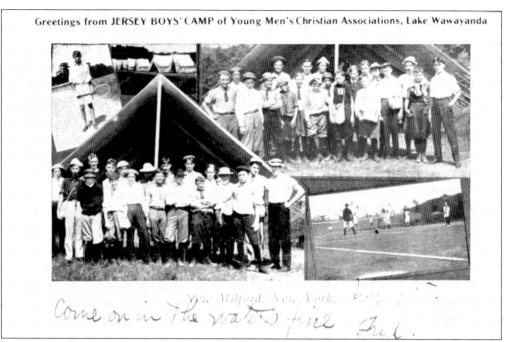

Greetings from JERSEY BOYS' CAMP of Young Men's Christian Associations, Lake Wawayanda

Come on in the water fine Fred.

A JERSEY BOYS' CAMP, LAKE WAWAYANDA. The Newark YMCA operated a boys' summer camp at Lake Wawayanda from 1886 to 1891 and again from 1901 to 1919. This multiview postcard shows camp activities *c.* 1908. (Author's collection.)

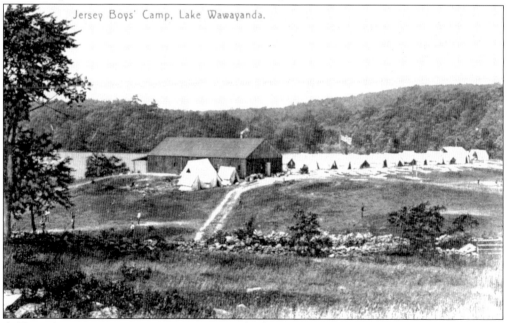

Jersey Boys' Camp, Lake Wawayanda.

A TENT CAMP ON THE SAND SHORE. In its early days, Camp Wawayanda was located on a bluff on the Sand Shore, as shown here. It later expanded across the lake to the east shore. This sandy bluff, which included a prehistoric Native American campsite, was bulldozed flat in the late 1960s to create the present public beach area and parking lot at Wawayanda State Park. (Courtesy Marcela T. Gross.)

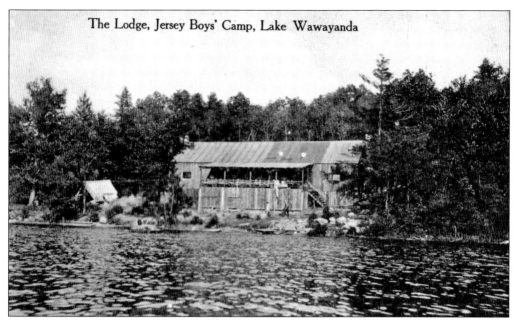

The Lodge, Jersey Boys' Camp, Lake Wawayanda

A LODGE AT THE YMCA CAMP. A large, permanent lodge was built at Camp Wawayanda c. 1906. It stood on the eastern shore of the lake in the cove near the main dam. It was used for dining, assemblies, and a wood shop. (Author's collection.)

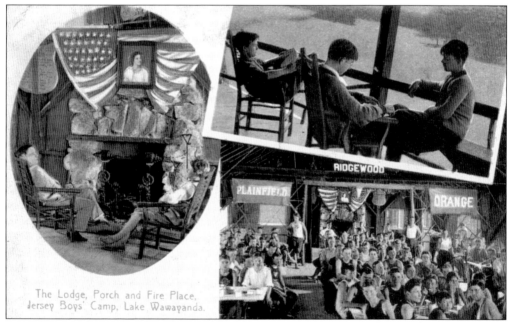

The Lodge, Porch and Fire Place, Jersey Boys' Camp, Lake Wawayanda.

RIDGEWOOD

PLAINFIELD

ORANGE

INSIDE THE LODGE. Seen here are interior views of the lodge at Camp Wawayanda, which included a broad veranda overlooking the lake. The fireplace was undoubtedly a popular spot on rainy days. The lodge seems to have vanished soon after the YMCA left Wawayanda in 1919, and only some of its foundations are visible today. (Courtesy Wayne T. McCabe.)

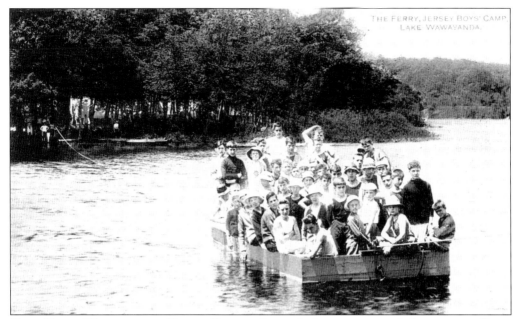

THE CAMP WAWAYANDA CABLE FERRY. One of the most noted features at Camp Wawayanda was a cable ferry that carried campers between the lodge and the auxiliary camp on nearby Scott Island, named after Charles R. Scott, who ran the camp after 1901. (Courtesy Marcela T. Gross.)

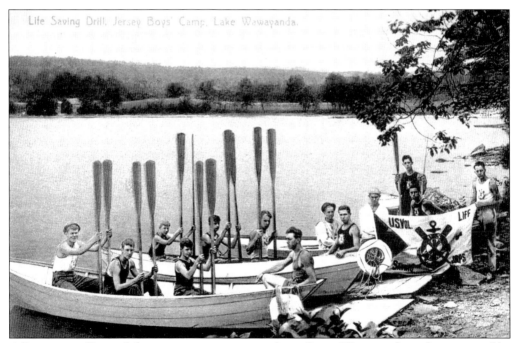

A LIFESAVING DRILL. Lifesaving courses were popular at Camp Wawayanda, as demonstrated by this *c.* 1910 view. The Boy Scouts of America visited Camp Wawayanda and used its programs to develop their own lifesaving instruction. In the distance is the shore where the present beach and boat-launch areas are located. (Courtesy Marcela T. Gross.)

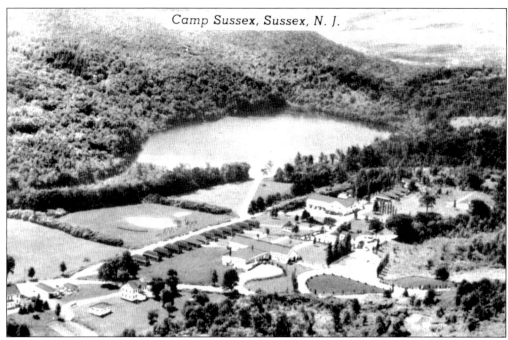

Camp Sussex, Sussex, N. J.

FRESH AIR FOR CITY CHILDREN. Camp Sussex opened in 1924 at the old Carpenter Farm on Lake Glenwood. Hundreds of underprivileged city children still attend camp here each summer, free of charge. (Courtesy Wayne T. McCabe.)

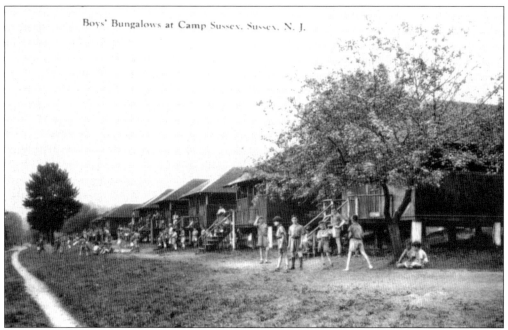

Boys' Bungalows at Camp Sussex, Sussex, N. J.

BUNGALOW ROW. City youngsters staying at Camp Sussex lodged in this row of bungalows. The camp could accommodate 400 children at a time, with some 1,200 using the camp over the summer season. The many thousands of children who have stayed at Camp Sussex include some later notables such as Mel Brooks. (Courtesy Marcela T. Gross.)

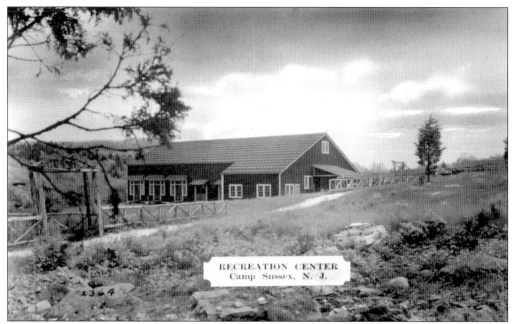

THE BIGGEST THEATER. When built in 1926, the recreation building and theater at Camp Sussex included a 1,000-seat auditorium with a 60-foot stage, the largest such facility in Sussex County at the time. It later suffered a fire and was rebuilt. (Courtesy Marcela T. Gross.)

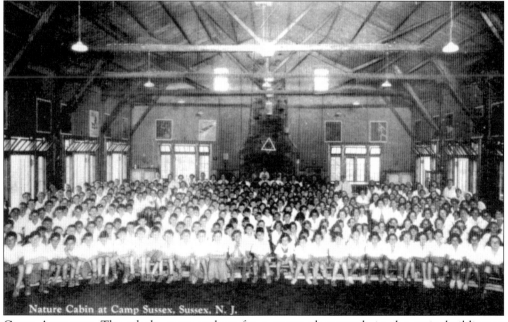

CAMP ASSEMBLY. The whole camp gathers for a group photograph in the main building at Camp Sussex. As indicated by the Star of David on the chimney, Camp Sussex was a Jewish philanthropic endeavor. Its headquarters were located in New York City. However, it always provided its services free of charge to underprivileged children regardless of their faith. (Courtesy Harvey Barlow.)

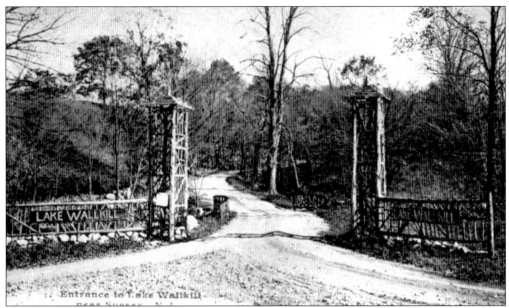

A RUSTIC WELCOME. This elaborate rustic-work gate originally greeted owners and visitors to Lake Wallkill, a summer cabin development begun in 1926 by a group of businessmen from the borough of Sussex. Construction only took off when the Paterson partnership of Seckler & Shepperd joined in 1929, the year that Lake Wallkill formally opened. (Courtesy Marcela T. Gross.)

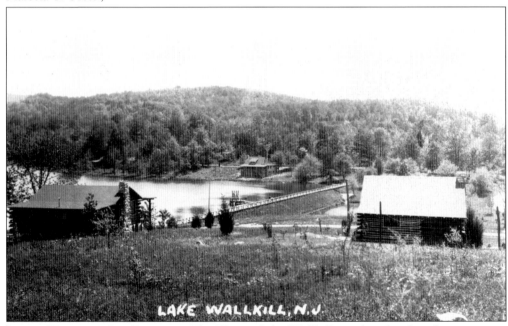

IN THE HEART OF OLD POCHUNG. The 50-acre Lake Wallkill was first developed as a summer community in 1926. Area lakes had attracted local families as summer retreats since the 1870s, but with better highway access, people from the cities could now buy a weekend home in places like Vernon. Lake Wallkill's dam, boardwalk, and diving dock are seen here *c.* 1935. (Courtesy Wayne T. McCabe.)

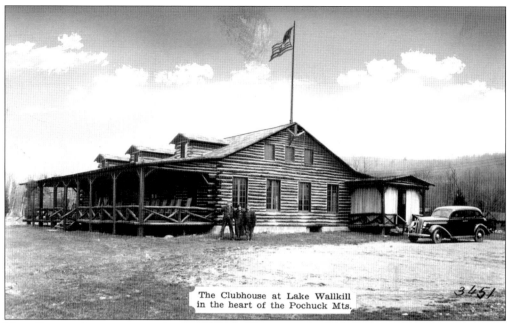

The Clubhouse at Lake Wallkill
in the heart of the Pochuck Mts.

NEW JERSEY ADIRONDACK. One of the features of Lake Wallkill was this handsome log clubhouse, constructed in 1929. Such log construction was popular in the early lake resorts and often utilized dead standing chestnut that was killed by the chestnut blight a decade earlier. This clubhouse is still in use. (Courtesy Marcela T. Gross.)

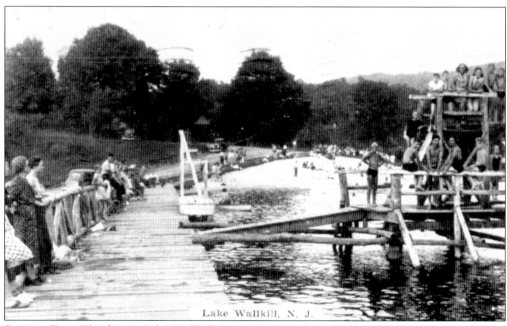

Lake Wallkill, N. J.

SUMMER FUN. The dam at Lake Wallkill featured a rustic boardwalk and a diving pier, as did the later one at Highland Lakes. Both were popular places to go on a warm summer day, as attested to by this 1930s postcard. (Author's collection.)

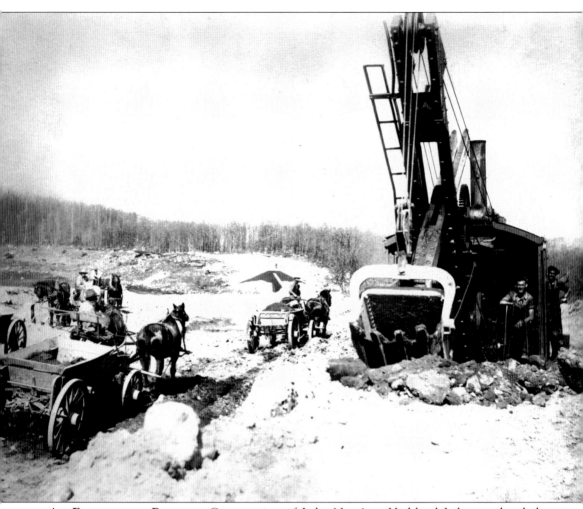

AN ENTERPRISING BALDWIN. Construction of Lake No. 1 at Highland Lakes predated the rest of the community by seven years. Excavation for it began in the summer of 1928, as seen in this photograph. The owner and operator of the steam shovel is Robert F. Baldwin Sr., progenitor of Baldwin Enterprises in Vernon. The steam shovel was brought up, under its own power, from Vernon via Breakneck Road. At times, workmen had to use the bucket arm to push the machine backward up the steep dirt road; the trip took three days. The steam shovel dumped dirt into mule-drawn wagons that carted it away for use in constructing the dam, whose concrete abutments and core wall can be seen in the distance. This photograph was taken from roughly where Beach No. 1 is today. (Courtesy Vernon Township Historical Society.)

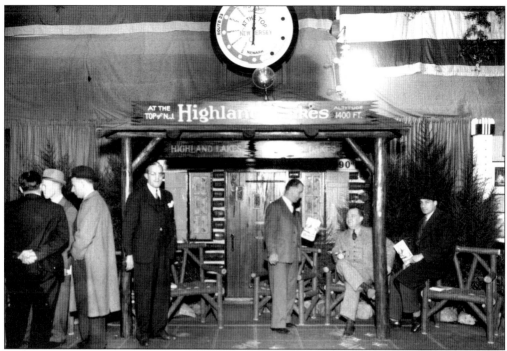

"RUSTIC CABINS & PLOT FROM $990." The developers of Highland Lakes operated a booth at the home show at Madison Square Garden, which is the likely location of this shot. A little faux cabin and front porch with real potted pine trees and Adirondack-style chairs set the tone of rustic relaxation. Seated, with stogie in hand, is S. Clayton Shepperd, or "Shep," as he was universally known, one of the founding developers. (Courtesy Highland Lakes Country Club.)

"EASY TO REACH." This c. 1936 flyer and road map describes Highland Lakes as easy to reach, and so it was. The construction of the George Washington Bridge in 1931, along with various other highway improvements, made the New Jersey hinterlands far more accessible to those coming from the boroughs of New York City. In 1938, a trip by car from the Bronx to Highland Lakes took a mere three hours. (Author's collection.)

From Mountain Farms to Summer Resort. This *c.* 1936 aerial photograph shows the area around the intersection of Highland Lakes and Breakneck Roads, where the post office and Seckler & Shepperd office were located and where Beach No. 1 still is today. Even with such features as a beach and tennis courts, the landscape still looks like an old, overgrown mountain farm, which it was. The beach, lake, and tennis courts are among the few features that remain unchanged today. To the rear of the old post office site (not yet built when this photograph was taken) are sheds and barns used as storage and workshops by Seckler & Shepperd. They later burned. (Courtesy Highland Lakes Country Club.)

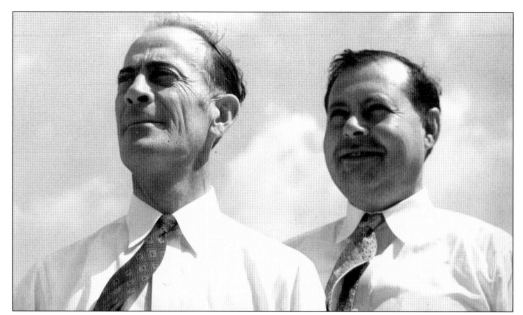

MEN OF VISION. Herb Smith (left) and John R. Seckler (right) were important figures in the development of Highland Lakes. Seckler was partner with S. Clayton Shepperd in Seckler & Shepperd, a real estate development and sales business that started Highland Lakes in 1935. Smith was the architect responsible for the rustic charm of the Highland Lakes cabins in the 1930s. (Courtesy Highland Lakes Country Club.)

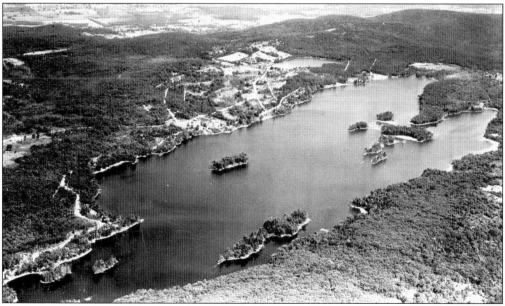

AN AERIAL VIEW, HIGHLAND LAKE. In the mid-1930s, the developing firm Seckler & Shepperd bought up thousands of acres of old mountain farms and forest in the Parker's and Cherry Ridge sections of Vernon Township. In 1936, they began Highland Lake, so named because it was located near the highest point in the Highlands. This *c.* 1938 aerial view shows the completed lake when little but the western shore had been developed. (Courtesy Highland Lakes Country Club.)

GOODBYE BRUSHY MEADOW, HELLO HIGHLAND LAKE. For generations, this area was a vast expanse of marshland called the Brushy Meadow. Starting in late 1935, it became Highland Lake. This view from the main dam was taken on August 30, 1936, when the lake was still far from full and the shoreline was choked with brush and timber from clearing the lake bed. The lake did not fill completely until 1937. (Courtesy Highland Lakes Country Club.)

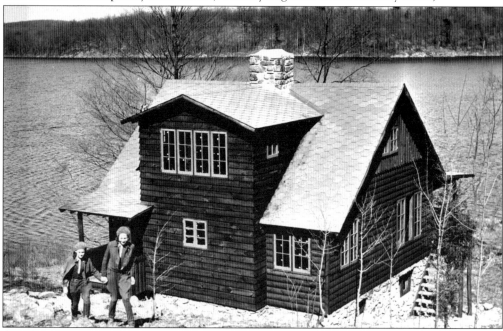

AN EARLY LAKESIDE CUSTOM. Not all early cabins at Highland Lakes were log. Many were frame with rustic siding, such as this home on Lakeside Drive West, shown c. 1938. In the 1930s and early 1940s, most homes at Highland Lakes were fairly unique in design. In the postwar period, standardized designs with varying options came to be the rule. Note that the far shore, now East Lakeside Drive, is completely undeveloped in this view. (Courtesy Highland Lakes Country Club.)

116

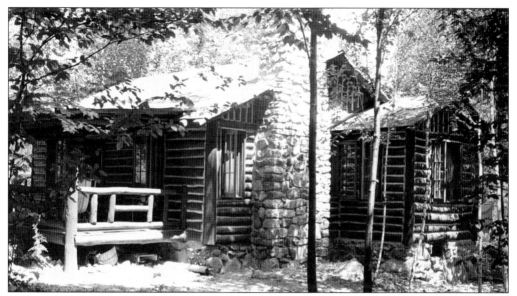

A Shaded Retreat. This early Highland Lakes cabin exemplifies early lake-community log architecture. Typical features included horizontal logs for walls, vertical or diagonal logs for gables, a rustic-work porch, and a rough-stone foundation and chimney. Favored for their rustic, pioneer feel, such cabins in fact bore little or no resemblance to the cabins built by early Vernon settlers, who used squared logs. Lake cabins rather emulated the log architecture of the Adirondacks and of the American West. (Courtesy Highland Lakes Country Club.)

Warmth on a Rainy Night. Most Vernon summer cabins included a massive stone fireplace like the one in this 1939 photograph from Highland Lakes. Though not well suited to heating a whole cabin in the dead of winter, they were (and still are) a lovely companion on a cool summer night or a frosty autumn morning. (Courtesy Highland Lakes Country Club.)

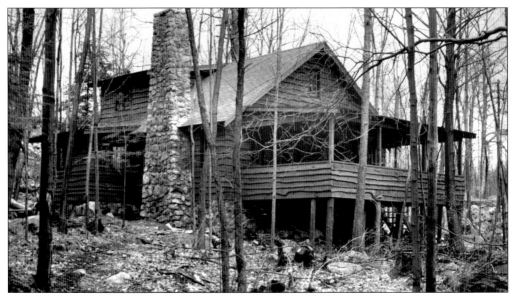

A Resort Home, Highland Lakes. When Seckler & Shepperd developed Highland Lakes in the 1930s, it was primarily for summer vacation homes, and their architectural scheme was suitably rustic and warm. This *c.* 1938 postcard view of a typical cabin shows the wood siding, massive stone chimneys, casual layout, and forested setting that were hallmarks of Seckler & Shepperd's summer cabins. (Courtesy Highland Lakes Country Club.)

From Dairying to Dancing. Seckler & Shepperd took two barns on the old Parker Farm, located at the intersection of present-day Highland Lakes and Breakneck Roads, and converted them into a clubhouse. Dating to the 1800s, the barns were clad in rustic siding and given massive chimneys. Barn features such as the ventilator cupola and the hay hood were left intact. (Author's collection.)

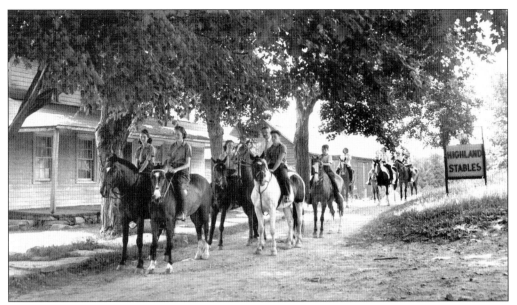

THE HIGHLAND STABLES. The Paddock family built this house, still standing at the intersection of Canistear and Cherry Ridge Roads, in the 1790s, and it was enlarged by Henry Young in the 1840s. Serving as the local post office in the 1890s, in the 1930s it was owned by the Marsh family, who offered horseback riding to nearby residents of Highland Lakes. (Courtesy Highland Lakes Country Club.)

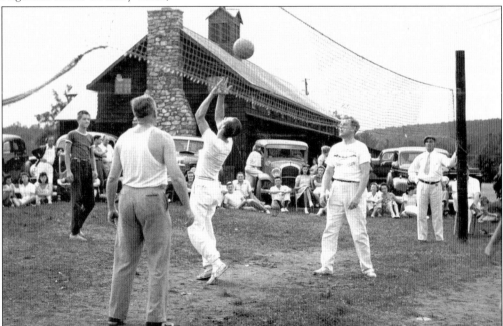

A HIGHLAND LAKES HOTSPOT. For decades, the Seckler building, as the original clubhouse was known, was a center of Highland Lakes activity, including sporting events, dances, a canteen, a laundromat, and Sunday church services. In later years, it became the Seckler & Shepperd Real Estate office. Long neglected and dilapidated, the once charming landmark was demolished in 1997. (Courtesy Highland Lakes Country Club.)

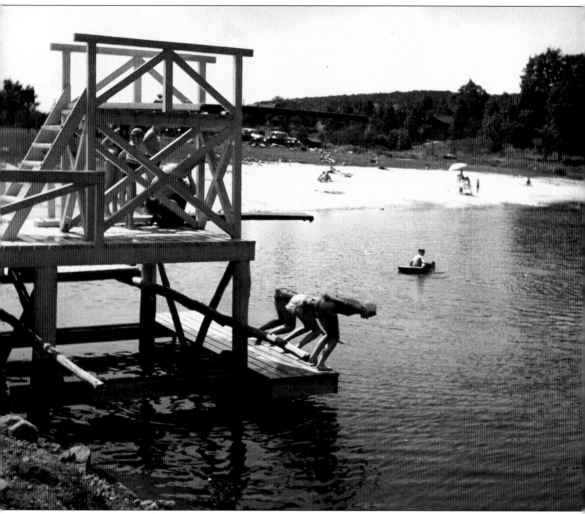

READY, SET, GO! The diving dock at the dam at Beach No. 1 in Highland Lakes is featured in this 1930s view, which was published as a postcard at the time and became quite well known. The diving dock was a popular feature of the beach until the 1970s, when the Army Corps of Engineers decreed that dams have no structures of any kind on them, and the diving dock was removed. Organized sports were, and still are, an important aspect of life in many Vernon lake communities. (Courtesy Highland Lakes Country Club.)

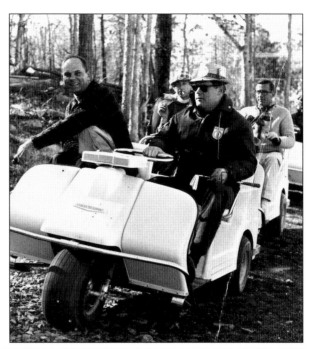

GREAT GORGE FOUNDERS. These four men were founding partners of Great Gorge Ski Area in 1965 and brought the modern era of resort recreation to Vernon. From left to right are the following: (front row) John L. Kurlander, president, and Matthew P. Baker, chief engineer; (back row) Albert A. Stasium, director of public relations, and John F. Fitzgerald, vice president. Taking a break from the slopes, they are on the golf course at High Point Country Club in Montague. (Courtesy Jack and Peg Kurlander and Anne Fitzgerald.)

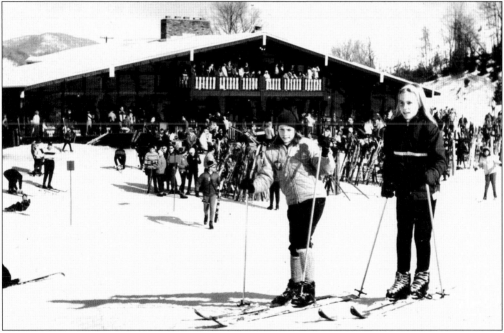

THE FIRST SEASON AT GREAT GORGE. The main lodge at Great Gorge Ski Area (now Mountain Creek South Lodge) is seen here from the rear during its first year of operation in the winter of 1965–1966. The ski area cost $1 million to construct. The lodge was designed by Alexander McIlvaine of the American Institute of Architects, and the ski slopes were designed by Otto Schneibs. Both men were noted designers of ski resorts. In 1965, an all-day ticket cost a whopping $4.50 and a pass on the weekend cost $6.50. (Courtesy Jack and Peg Kurlander and Anne Fitzgerald.)

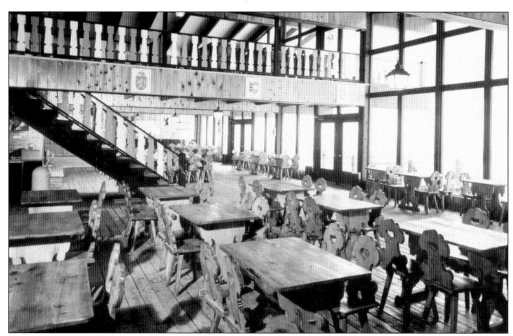

AUTHENTIC ALPINE ATMOSPHERE. The cafeteria in the main lodge at Great Gorge Ski Area is seen in this 1965 photograph. The decor was not ersatz Alpine, either. The chairs, tables, paintings, windows, and other furnishings all came from the Swiss Pavilion at the 1964–1965 World's Fair in Flushing Meadows, New York, which the developers of Great Gorge bought in its entirety when the fair closed in late 1965. (Courtesy Jack and Peg Kurlander and Anne Fitzgerald.)

RESORT RETAIL. The main lodge at Great Gorge Ski Area featured a retail store specializing in ski apparel and accessories. The Great Gorge Ski Shop was managed by one of the resort's founders, Anne Fitzgerald. (Courtesy Jack and Peg Kurlander and Anne Fitzgerald.)

APRÈS-SKI WARMTH. The main lodge at Great Gorge Ski Area featured a massive fireplace, the perfect spot for a hot drink after skiing. The paintings came from the Swiss pavilion at the World's Fair. The cozy guests were in fact employees hastily recruited for this publicity shot. (Courtesy Jack and Peg Kurlander and Anne Fitzgerald.)

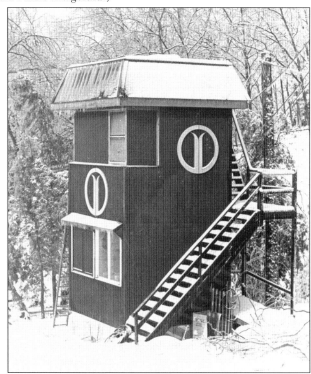

THE RACE TOWER AT GREAT GORGE. Located halfway up the mountain at Great Gorge Ski Area, the race tower contained timing apparatus, electronics, closed-circuit television equipment, and observation areas for the many ski races held. Numerous school, state, and professional races were held at the ski area, with both video and data being relayed to the main lodge for the enjoyment of viewers. (Courtesy Jack and Peg Kurlander and Anne Fitzgerald.)

THE MOUNTAIN CREW. Shown here is the *c.* 1971 Great Gorge mountain crew, in charge of maintaining chairlifts, snowmaking apparatus, lights, and other slope-side matters. At the far right is Charlie O'Brien, longtime mountain manager, with a lion cub from the Bob Dietch Zoo, which exhibited there in the summer. Among the others on the back of the truck (a former Pine Island fire truck) is Buddy "Indian" Paugh, who also had a long career on the mountain crew. (Courtesy Jack and Peg Kurlander and Anne Fitzgerald.)

VERNON VALLEY UNDER CONSTRUCTION. This 1967 photograph shows Robert Blenis, mountain manager, and George Zupo working on assembly of a pylon at Vernon Valley Ski Area (now Mountain Creek). In the background, the Ski Wee building is nearly completed and the frame has just begun to rise on the main base lodge, long known as the Hex for its hexagonal shape. The Hex burned down in 1999. (Courtesy Jamie May.)

HELP FROM ABOVE. At both Great Gorge and Vernon Valley ski areas, commercial lifting helicopters were used to raise and set in place ski-lift pylons at remote locations on the mountainside. This 1967 photograph shows assembly of ski-lift pylons at Vernon Valley Ski Area, then under construction. (Courtesy Jamie May.)

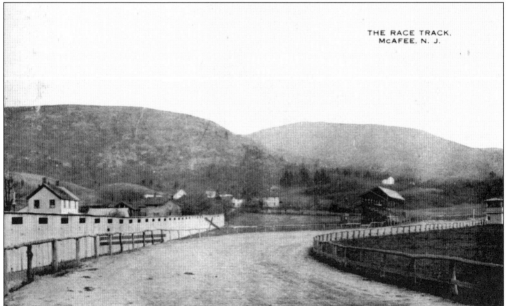

STOCK-CAR RACING FOR MCAFEE? The McAfee Racetrack, seen here c. 1917, had closed by the 1930s, as the automobile superseded the horse and trotting races faded away. The track was revived for stock-car racing in the 1950s, and there was a 1971 proposal to revive it again for auto racing, as McAfee's resort industry grew in importance. The attempt failed, and no trace of the racetrack is to be seen today. (Courtesy Harvey Barlow.)

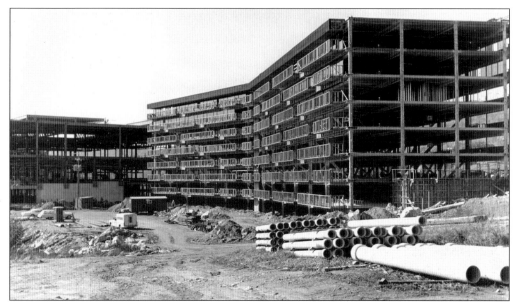

GETTING READY FOR HEF. Playboy Clubs International announced plans for a $20 million resort on the old Bethlehem Steel limestone quarry property at McAfee in 1968. By 1970, steel girders were rising high, and the 700-room hotel's grand opening was in December 1971. Among the celebrities to visit was, of course, Hugh Hefner. (Courtesy Marcela T. Gross.)

CAN RABBITS REALLY SKI? Executives of the new Playboy Club Hotel, along with two of the famed bunnies, pose with Peggy Kurlander (far left) on the slopes of Great Gorge Ski Area in this *c.* 1971 photograph. Early on, the ski industry and Playboy cooperated in marketing and promoting McAfee as a destination resort. (Courtesy Jack and Peg Kurlander and Anne Fitzgerald.)

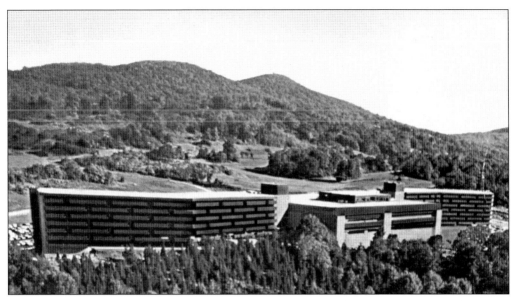

"THE TOTAL RESORT." Playboy officials advertised their hotel at McAfee as the "total resort." It had shops, a cabaret, big-name entertainers, restaurants, and cafes. With architecture that was strikingly modern yet rustic in a contemporary way, the hotel was almost grand enough to distract you from the famous bunnies. But it was never consistently profitable, and a much-rumored casino in the hotel never became a reality. Playboy sold the hotel in 1982. (Courtesy Wayne T. McCabe.)

CONTEMPORARY RUSTIC. The vast main lobby of the Playboy Club Hotel featured terraces with rocks and plantings, subdued lighting, and hanging rectangular wooden pendants that provided both a cavernous and forestlike feeling. This dramatic ceiling was later removed and replaced with a skylight. (Courtesy Wayne T. McCabe.)

SELECTED BIBLIOGRAPHY

Beers, Frederick W. *State Atlas of New Jersey*. New York: Beers, Comstock & Cline, 1876.

Coles, Dr. Roswell S. Notebooks on Vernon History. Originals in the collections of the Vernon Township Historical Society.

Decker, Ralph. *Then and Now: 40 Years in the Schools of Sussex County*. Privately published, c. 1942.

Dupont, Ronald J. Jr., *Vernon 200: A Bicentennial History of the Township of Vernon, New Jersey, 1792–1992*. McAfee, New Jersey: the Friends of the Dorothy E. Henry Library, 1992.

Edsall, Benjamin B. *The First Sussex Centenary*. Newark: A.L. Dennis & Brother, 1854.

Haines, Rev. Alanson A. *Hardyston Memorial*. Newton, New Jersey: New Jersey Herald Print, 1888.

Highland Lakes 1936–1986. Highland Lakes Country Club and Community Association, 1986.

Honeyman, A. Van Doren, ed. *Northwestern New Jersey: A History*, Vol. I. New York: Lewis Publishing Company, 1927.

Hopkins, G.M. Jr. *Map of Sussex County, New Jersey*. Philadelphia: Carlos Allen, M.D., Publisher, 1860.

Masker, Beatrice. *History of Education in Vernon Township*. (The author taught in the Glenwood School for many years.) Privately printed typescript, c. 1963.

Ransom, James M. *Vanishing Ironworks of the Ramapos*. New Brunswick, New Jersey: Rutgers University Press, 1966.

Snell, James P., et al. *History of Sussex and Warren Counties, New Jersey*. Philadelphia, Pennsylvania: Everts & Peck, 1881. Reprinted by Genealogical Researchers, Washington, New Jersey, 1981.

Swayze, Francis J. *Historical Address, Sesqui-Centennial, Sussex County, N.J.* Newton, New Jersey: the New Jersey Herald, 1903.

Sweetman, Jennie. Numerous articles and columns in the *New Jersey Herald* and the *New Jersey Sunday Herald*, c. 1969 to present.